T0273723

Line Color Form
The Language of Art and Design

ALLWORTH PRESS
NEW YORK

Jesse Day

Allworth Press books may be purchased in bulk at special discounts for sales promotion, corporate gifts, fund-raising, or educational purposes. Special editions can also be created to specifications. For details, contact the Special Sales Department, Allworth Press, 307 West 36th Street, 11th Floor, New York, NY 10018 or info@skyhorsepublishing.com.

27 26 25 24 13 12 11 10 9 8

Published by Allworth Press, an imprint of Skyhorse Publishing, Inc.
307 West 36th Street, 11th Floor, New York, NY 10018.

Allworth Press® is a registered trademark of Skyhorse Publishing, Inc.®, a Delaware corporation.

www.allworth.com

Cover and interior design by Jesse Day
Graphic design by Soo Jin Kang

Library of Congress Cataloging-in-Publication Data is available on file.
ISBN: 978-1-62153-244-6

Printed in China

The beginning of wisdom is calling things by their right name.

John Dillow, high school geometry teacher

Contents

Acknowledgments

To begin with, I must express my immeasurable gratitude to my chief collaborator and co-visionary Soo Jin Kang. Not only did Soo Jin graciously dedicate countless hours of creative energy to the graphic design and layout of this book, but as a student of both art and the English language, she provided the invaluable service of keeping me grounded in the audience and their needs. Since the inception of this project, Soo Jin has kept a constant eye on my blind spots, provided clever solutions to a host of baffling problems, and demonstrated the remarkable courage to shoot down so many of my brilliant ideas. This book would not have been possible without her.

To my wife, Ananda Day Cavalli, who provided the majority of the still life and landscape photography for the book, who spent the Fourth of July with me designing the cover, who nourished the project from its infancy with a bottomless well of encouragement, and whose insightful counsel helped steer me around the most impervious of roadblocks, my gratitude knows no bounds.

So many of my colleagues and friends at Parsons have supported me through this project, from offering practical advice to piloting my materials in their classes, that it would be impossible to list you all by name, but you are all enormously appreciated. A special thank you to Anne Gaines, Joe Hosking, Jaclyn Lovell, and especially Caitlin Morgan, who championed this project from day one and would not give up until it found its way into the right hands. I would also like to extend my debt of gratitude to The New School Office of the Provost, whose generous grant of the Innovations in Education Fund provided the fuel to turn this spark of an idea into a full-blown fire.

Finally, I would like to thank my students, whose magnificent blend of imagination and tenacity has so inspired me over the years. This book is my gift to you, and I hope that it makes the art and design school experience more enriching and enjoyable for all those to come.

Introduction
A Visual Guide for Visual Learners

I first came up with the idea to create a visual guide to the language of art and design during a tutoring session with a South Korean communications design student. She had chosen Van Gogh's *Starry Night* as her inspiration for a project and we were working together on a formal analysis of the piece. I was trying to elicit descriptive vocabulary from her so that she could explain, in her own words, what it was about the colors, lines, or composition of the piece that had so inspired her.

She stared in silence at the painting for a little while. Then she took a deep breath, glanced shyly at me, and whispered, "Blue?"

"Yes, but what about the blue?"

"It's . . . beautiful."

"Anything else?"

"Yellow?"

"How about the lines?"

She bit her lip. "Curved?" she asked.

Here was a bright young woman, an accomplished painter, a gifted designer studying at Parsons, a top art and design school in New York City, and she was utterly incapable of describing what was right before her eyes. It wasn't her fault. When would she ever have learned the words for swirling and spiraling lines, heavily caked pigment, splotched and smeared brushstrokes? And the colors! The lemon yellow stars and the saffron moon, the intermingling cobalt and cornflower blues that spin above that darkest bistre landscape. Never in her first-rate private art education had she had the opportunity to learn how to talk about art. A picture is worth a thousand words, but where do we get those words when we want to discuss the picture?

I reached out to a number of colleagues at art and design colleges across the country, and sure enough this was a problem that seemed to plague international students everywhere. What I was surprised to discover, however, is how much difficulty native speakers were having as well. Any writer will tell you that simply describing what you see in front of you is one of the hardest things to do. It is certainly a language problem, but it is also a "way-of-thinking" problem. Visually oriented people, whether English is their first language or not, often have trouble expressing themselves linguistically because they are more comfortable communicating in images. Vision precedes language in our psychic

development, and for many artistic people it remains the dominant mode of conceptualization throughout our lives. We think in pictures. Translating picture to language is a daunting task, one that is even more challenging for non-native speakers who are juggling three languages: *native tongue, English,* and *image.* What is needed, I thought, is some sort of image-to-word translation book for the language of art and design. The idea seemed pretty obvious, and I was shocked to discover that one didn't already exist, but at the time I had no idea how to go about creating such a thing.

Many people think of the verbal and the visual as being totally separate, disconnected modes of thinking. People tend to self-identify as either artistic or intellectual. This identification is usually established in childhood, the result of a natural talent or affinity for one path or the other and the accompanying praise or discouragement from parents and teachers. This self-imposed division not only sells us short of our full potential, it has caused many communication problems in the realm of art and design education. In the academic community of students and teachers, we have a lot of "intellectuals" who write brilliant analytical prose, but package it in dense tomes that are impenetrable to the "visuals," and a lot of artists who make beautiful work, but can't explain its significance to the "verbals." Our design libraries are filled with exhaustive treatises on color theory that contain but one or two pictures, and superficial image books with but a few lines of unhelpful text. Every year the images look more sparkly, the textbooks look more musty, and these two icebergs drift further apart.

My goal with this book was to create a pedagogical resource that could help the visual and the verbal find a common tongue, a sort of Rosetta Stone beginning with the most basic fundamentals of visual language. In the increasingly global market of art and design, in which English and "image" are the two most universal languages, this seems sorely needed. Beyond reinvigorating our discourse with both beauty and depth, the practical applications are undeniable. Art students have to be able to respond to critique from their teachers. Design students have to interact with mentors. Professional artists and designers have to work with collaborators and clients. Everyone has to be able to explain their vision if they ever want to get any funding or support. What rich conversations we could have if we were all more able to speak a common language!

But how to do it?

Besides the dichotomy between visual and verbal thinking, there is another issue that makes modern education challenging: speed. Young people today have a whole universe of information at their fingertips and they navigate through a swirling kaleidoscopic mosaic of imagery and text at an amazing rate. Movement back and forth between visual mediums is

instantaneous and seamless. Within the span of a thirty-minute lunch, a design student will choose a meal from a glossy set of ramen photos, update her Facebook status to "lunchtime :)," look up the meaning of *kamaboko* on Wikipedia, glance at a pdf of her reading for class while she waits, document the meal when it arrives on Instagram with an appropriately oriental-looking lens filter, sketch an idea for a new chopstick design on a napkin while waiting for the check, take a picture of the napkin and upload it to her website, and then walk out into the street where she is bombarded from every direction by multicolored media messages and screaming rainbows of advertisement. The pulpy gray and black monotony of the written text is a very alien and inhospitable landscape.

Line Color Form: The Language of Art and Design is based on the premise that visual people, individuals who might struggle to find clarity in written and spoken rhetoric, are capable of grasping sophisticated concepts almost instantly if these concepts are presented in an intuitive and attractive manner. Similarly, more verbal people, despite their objections that they are "not artistic," are perfectly able to understand visual concepts if they are conveyed concisely and unpretentiously.

The fundamental theory behind this book, proven time and again by advertisers, is that when a word is combined with an image it forges a much deeper link in the mind. In my efforts to build a new pedagogical tool that resonates with the rapid informational exchange of the twenty-first century, I have borrowed heavily from those media makers whose clear messages have risen above the chaos. Think of an Apple ad, seamlessly joining a sleek product photo with a few well-chosen words to communicate a sophisticated message that is immediately and completely understood by everyone.

I have made every effort to communicate the lexicon contained in this book in a visually appealing and quickly digestible manner. Wherever possible I have illustrated concepts with easy-to-read charts, graphics, photographs, and images from art history. I have strived to un-clutter the page so that it displays information cleanly, in a pure form that can be comprehended at the speed of sight. Our culture is able, and indeed prefers, to absorb information very rapidly, but that does not mean our ideas and concepts must be simplistic. It is my conviction that with the right combination of text and image, students can be pulled back from the reductive practice of simply looking, to the much more meaningful act of analyzing, interpreting, and then creating.

How to Use This Book

Formally analyzing art is like looking through several different pairs of binoculars, each of which allows us to see only one aspect at a time. Like the heat waves visible through infrared goggles, these lenses let you see the colors, the lines, or the textures of the materials in perfect relief, without being distracted by anything else. This way of seeing may seem unnatural at first, but in time you will find that it leads to a much deeper understanding of how each aspect is functioning, and ultimately to an understanding of how all the aspects function together as a whole. The chapters of this book provide the language needed to describe what we can see through each of these pairs of binoculars.

In the first four chapters, the formal qualities of art and design are divided into four broad categories: line, color, composition, and material. Each chapter begins by presenting the fundamental vocabulary pertaining to a discussion of the given aspect. The Color chapter, for example, opens with a series of color wheels that concisely identify every shade and gradation of the rainbow from aquamarine to fuchsia. Terminology for concepts such as value, saturation, and interaction is communicated with representational graphics and schematics. This learning or "acquisition" section can be used in a variety of ways: You can read it as a study guide; you can use the book in real time while you are actually studying a piece of art or design, looking closely at the piece and matching your observations to the vocabulary and concepts in each chapter; or you can use the book as a reference while you are writing an essay to help you find the exact words to articulate what you want to say. No matter how you use it, the combination of picture and text is intended to give you an image-sense of art and design vocabulary and concepts. This will not only give you a deeper understanding and ownership of the words, but it will also develop your ability to see greater depth in the artworks themselves.

In each chapter, the acquisition section is followed by an "application" section, which demonstrates how this language is applied in an analytical sense. "Color" concludes with a series of color palettes, such as cool, warm, dynamic, vibrant, pastel, and earthy. These palettes are coupled with paintings from art history that exemplify the given palette, and each image/palette pairing is accompanied by a descriptive paragraph that offers an example of how to apply the vocabulary in visual analysis. These visual analysis paragraphs demonstrate how to connect your observations in order to arrive at a more complete understanding of how different aspects of a work affect its overall "feel" and

meaning. Reading these paragraphs will also help you get a sense of how to organize your observations into clear writing. A great exercise to help you solidify your mastery of the language is to choose your own examples of art or design, pieces that inspire you, and discuss them with other people, or write your own analytical paragraphs about them. Use as much of the vocabulary from the chapter as you can, but write in your own style and tone. Take this opportunity to explore what sort of effect different colors, lines, and materials have on you. What sort of emotions and ideas arise when you gaze at a bold streak of crimson or a gentle daub of cool emerald green? When you conduct a formal analysis you learn as much about yourself as you do about art.

The fifth chapter, *Formal Analysis*, provides step-by-step instructions for how to integrate your ideas and observations into a well-organized piece of writing. This is where your analysis of line, color, and form come together to create meaning. The chapter addresses essential concepts such as how to write brief "snapshot" descriptions, how to conduct observations, how to organize a paragraph or an essay, and how to employ diverse vocabulary to generate meaning. Additionally, there are three sample essays and a "Frequently Asked Questions" section that addresses common stumbling blocks, such as thesis statements and conclusions. Art and design students who have to write formal analysis essays for their classes should read this chapter in its entirety and return to it as a reference whenever they are struggling to work their ideas into a paper.

The final section of the book is the appendix of useful terms and expressions. This section provides definitions and examples of popular terminology that is currently being employed in academic discussions surrounding visual culture. The appendix is not a comprehensive catalog of the specialized terminology of every field of art and design known to man, but rather a concise list of words you really ought to know if you want to participate confidently in academic critiques and professional discussions. After you have read the definitions and examples I have provided, you are encouraged once again to come up with your own examples and write your own sentences for each term. Where have you seen these concepts in your life? Which words do you like and how do you want to use them? After all, we are only able to truly make words our own after we have contextualized them within our own unique experiences.

Line Color Form

The Language of Art and Design

Line

CHAPTER 1

Defining Line

Lines are the most basic units of visual communication. Lines, curves, and angles begin to give shape to concepts, allowing them to take form and assert themselves on reality. From Euclidean geometry we derive idealized form in its purest two-dimensional and three-dimensional expression. Then we add the more subtle human elements of weight, motion, and style, and begin to explore the non-rational lines found in nature. A mastery of the terms used to describe lines, curves, and shapes is the foundation for any accurate discussion of art or design.

Weight

faint

light

thin

medium

bold

heavy

thick

broad

Line Style

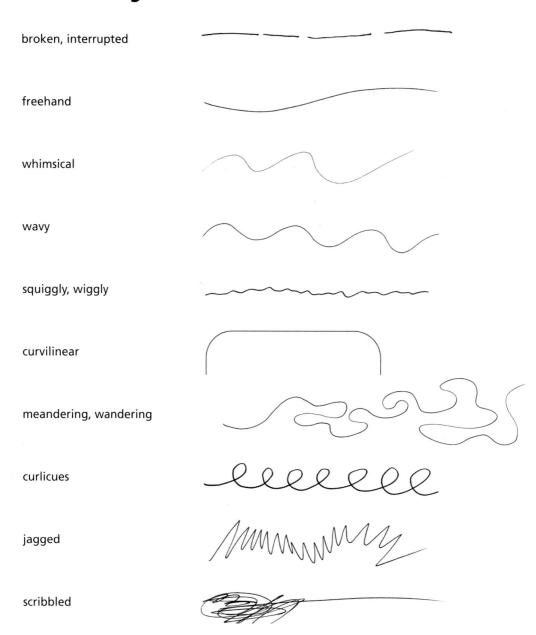

broken, interrupted

freehand

whimsical

wavy

squiggly, wiggly

curvilinear

meandering, wandering

curlicues

jagged

scribbled

Brushstrokes

splattered

splashed

dripped

dribbled

splotched

smeared

caked

delicate

blurred

streaked

Angle

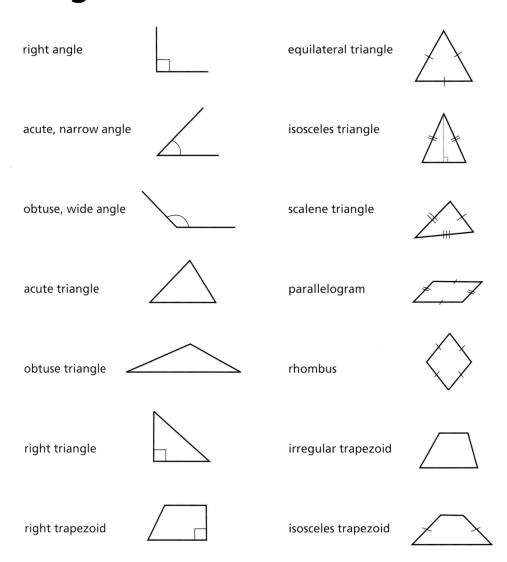

right angle

equilateral triangle

acute, narrow angle

isosceles triangle

obtuse, wide angle

scalene triangle

acute triangle

parallelogram

obtuse triangle

rhombus

right triangle

irregular trapezoid

right trapezoid

isosceles trapezoid

Shape

triangle

triangular prism

cone

square

rectangular prism

tetrahedron

pentagon

pentagonal prism

pyramid, pentahedron

hexagon

hexagonal prism

cube, hexahedron

octagon

octagonal prism

octahedron

circle

cylinder

sphere

Grid

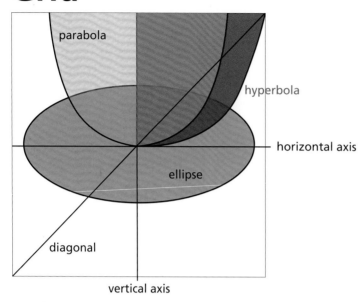

parabola

hyperbola

horizontal axis

ellipse

diagonal

vertical axis

Circle

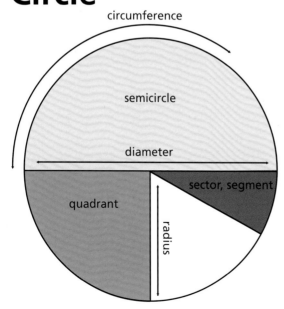

circumference

semicircle

diameter

sector, segment

quadrant

radius

2D

rounded corner
rounded edge

edge side

perimeter

3D

exterior

parallel
lines

face

interior

perpendicular
lines

corner

Wild Brushstrokes

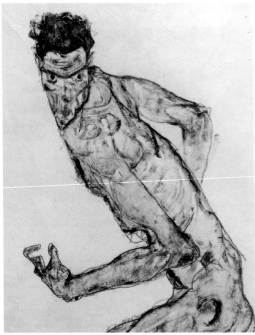

Fighter, Egon Schiele, 1913

aggressive

jagged

meandering

curlicues

heavy

blurry

streaks

frantic

This 1913 self-portrait by Egon Schiele is an excellent example of how line can communicate tension and emotion. The figure's awkward posture is rendered in fast **aggressive** lines, some thin, some thick, all **jagged** and unsteady. The hair on his thighs is created from a few quick **meandering curlicues**, a hurried suggestion of hair rather than a detailed depiction of it. Color too is applied in wide splotches with a **heavy** brushstroke or rubbed into the canvas in **blurry streaks**. The subject's haunted-eyed expression is one of shock, glaring over his shoulder at the viewer as if we just walked in on him in the middle of some incriminating act. The violence and vulnerability of this moment is communicated through the wild, **frantic** lines, as if Schiele were desperately trying to escape from his own physical body, even as he immortalized himself in paint.

Schematic Drawing

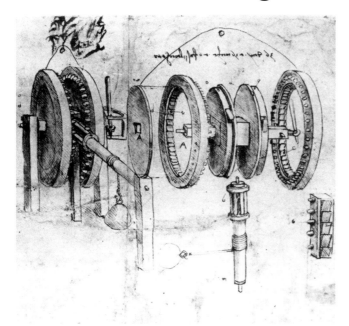

integrated

exploded

perimeter

rectangular

irregular

teeth

cylindrical

pegs

freehand

General and Exploded View of a Hoist, Leonardo da Vinci, circa 1500

This schematic drawing from the notebooks of Leonardo da Vinci provides two views of a machine, both as a functional **integrated** object and as a separated, or **exploded**, series of interlocking parts. This exploded view is the foundation of engineering design, still used today in everything from automobile assembly to Lego instructions. It is notable that Leonardo's drawing is more representational than precisely accurate. The curving **perimeters** of the various wheels are drawn with the **irregular** stroke of a quick hand. The **rectangular** teeth and the little **cylindrical pegs** are drawn **freehand**, approximating the idea of the shape rather than precisely rendering its geometric properties. The goal of this drawing is to communicate as clearly as possible the concept and function of the design, in such a way that a skilled machinist would have no trouble picking up where the artist left off and constructing a working machine.

Functionalism

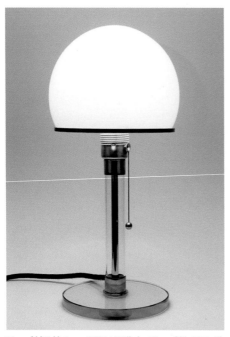

form

function

disk

cylinder

semispherical

user-centered

intuitive

Wagenfeld Table Lamp WG 24, Wilhelm Wagenfeld, 1924 Photo: Michael Hoefner

The *Wagenfeld Table Lamp* is a quintessential industrial design of the Bauhaus era and embodies the philosophy of functionalism. Broadly defined, the functionalist aesthetic demands that the **form** of an object should express its **function,** and that all unnecessary ornamentation should be omitted. This lamp is constructed from simple, undecorated geometric forms. A thick glass **disk** provides a sturdy base from which a transparent **cylinder** shoots up like the trunk of a tree to support a **semispherical** reflector bowl. The glass of the reflector bowl is opaque, seeming to hide the internal lighting mechanism, but actually providing the function of diffusing the light for a more balanced glow. The most noteworthy element of the lamp, however, is the simple pull-string on/off switch, a dangling metal cord with a tiny brass sphere on the end that screams "Pull me!," heralding the dawn of a new era of **user-centered**, **intuitive** design.

Curvilinear Design

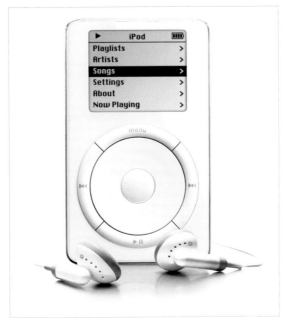

First Generation iPod, Apple Inc., 2001

scaled

rounded corners

rectangle

gradual curve

edges

concentric circles

cylinder

The smoothly shaped and intuitively navigable iPod was the beginning of Apple's user-centered design revolution. The iPod was designed with a sleek curving geometry and perfectly **scaled** to fit comfortably in the human hand. The basic form of the device is a thin **rectangle** with **rounded corners** and **gradually curving edges**. The screen is set inside a **round-cornered rectangle** that mimics the shape of the iPod itself, and the modern sans-serif font of the text is also soft and rounded. The primary curved rectangle form is complemented by several circular design elements, including the **concentric circles** of the control wheel and the "select" button. The earbuds, more notable for their shape than their sound quality, are composed of flattened **semispherical** disks affixed to small, pill-shaped **cylinders** that protect the electrical components, before connecting to the soft, rubber-sheathed wires. The entire design is **curvilinear** and smooth, in service of the belief that the product should be just as easy on the eye as it is easy to use.

Postmodern Sculpture

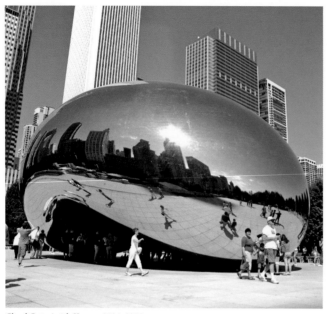

organic

seamless

continuous

curving

surface

ellipse

concave

perception

Cloud Gate, Anish Kapoor, 2004–2006

This public sculpture, located in the heart of Chicago's Millennium Park, was titled *Cloud Gate* by the artist, Anish Kapoor, but Chicagoans have nicknamed it "The Bean" for its distinct **organic** shape. A radical departure from the modernist aesthetic that dominates Chicago's skyscrapers, *Cloud Gate* embodies a postmodern sensibility, avoiding straight lines and definition. Constructed from 168 **seamlessly** welded stainless steel plates, the sculpture has no edge, but only a **continuously curving surface** generated by an infinite calculus of **ellipses**. As with other postmodern work, *Cloud Gate* deals with the **perception** and experience of the viewer. Visitors are able to walk around the entire sculpture, even passing beneath the **concave** underbelly of the piece, with each step revealing a new vision in the sculpture's mirrored surface. In a sense, the sculpture is not so much a new object in the city, but rather a portal to a new way of seeing the city and oneself within that environment.

Minimalist Installation

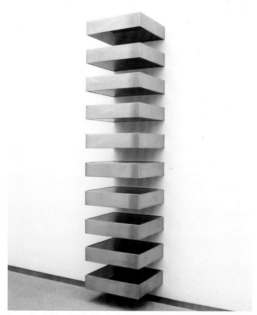

Large Stack, Donald Judd, 1968 Photo: Oliver Kurmis

identical

rectangular prism

exterior face

minimal

perspective

stanza

This piece is one of many similar sculptural installations by minimalist artist Donald Judd. The sculpture is composed of ten **identical rectangular prisms** of amber-colored Plexiglas, the **exterior face** enclosed in a heavy casing of stainless steel, and mounted directly on the museum wall. While the **minimal** presentation allows us to enjoy the pure qualities of the materials themselves, the installation also elegantly expresses the simple idea of **perspective**, as the viewer discovers how different the exact same shapes look when seen from varying angles. As one scans up and down the piece, each rectangular surface appears to be thinner or wider than the next, calling into question when, if ever, we are able to see the actual true nature of an object. With its **stanza**-like structure, the sculpture is not unlike a simple poem about the beauty and mystery of geometric form.

Concentric Circles

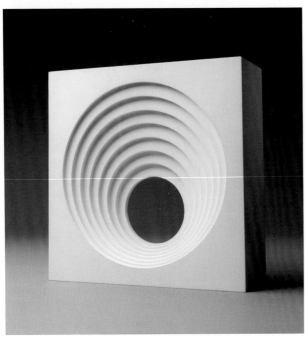

geometric

abstraction

slab-like

prism

inscribed

diameter

illusion

depth

Concentric Circles, Herbert Bayer, 1969/2010. Courtesy: Peyton Wright Gallery

Concentric Circles, by lesser-known Bauhaus artist Herbert Bayer, is a work of pure idealized **geometric abstraction**. Devoid of color, the powdercoated aluminum sculpture explores the effect that can be created by line and mass alone. A **slab-like square prism** is inscribed with a series of concentric circles of uniformly decreasing **diameter**. The technique of positioning the center of each circle lower than the next gives the illusion of great depth, a common trick of the eye used in illustration to create the sense that one is staring down a tunnel. This raises something of a puzzling contradiction, however, in the case of a sculpture that has actual physical **depth**. In fact, the illusion of depth is confounded by the physical reality of the object taking up space in the environment. As a three-dimensional object, existing in real space, it can never be any deeper than it is.

Honeycomb Architecture

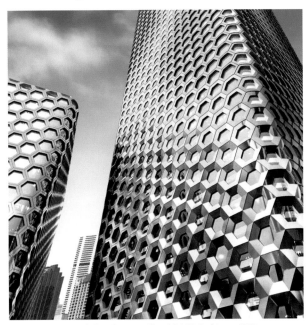

exterior

skin

hexagon

isosceles

trapezoid

horizontal

diagonal

vertical

plane

Sinosteel International Plaza (Tianjin, China), MAD Architects, 2012

The Sinosteel International Plaza in Tianjin is the latest in China's new wave of imaginative and experimental skyscrapers. The two buildings that make up the plaza, a shorter hotel and a towering 358-meter office building, have the basic form of rectangular prisms with a unique honeycomb **exterior skin** composed of thousands of interlocking **hexagons**. This hexagonal pattern serves both as a structural support and as a climate control system; the varying sizes of the hexagonal windows, each framed by six **isosceles trapezoids**, are intended to regulate both sunlight and heat, so as to balance the internal environment. Besides these functional attributes, the **horizontal** and **diagonal** lines of the hexagons cause the eye to travel left and right as one scans up the **vertical plane** of this massive structure. Finally, the corners and edges of the buildings are rounded, both to minimize wind pressure and to give the buildings a more natural, organic appearance.

Color

Hue and Mood

Of all the elements of visual expression, color is the one that most directly affects human emotion. Colors have different meanings to different cultures, and even two people within the same culture will see the same hues differently and have independent emotional responses to them. There is an infinite variety of shades of color perceivable to the human eye, but a finite number of color names. The colors listed in this book have been chosen for their frequent use in spoken and written American English, particularly with regard to discussions involving art and design. This chapter is meant to give you a greater command of vocabulary for expressing color and its effect, precisely as you see it.

18

Blue

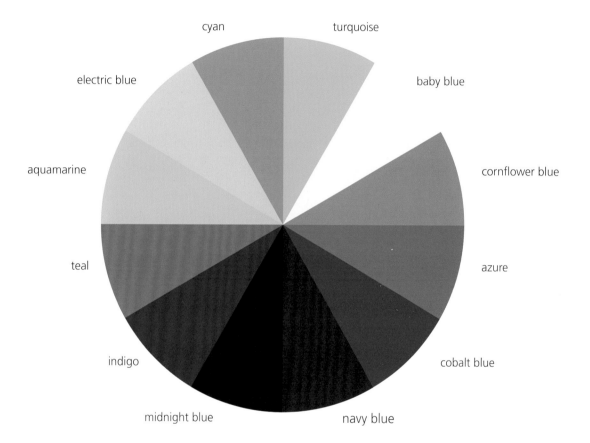

cyan

turquoise

electric blue

baby blue

aquamarine

cornflower blue

teal

azure

indigo

cobalt blue

midnight blue

navy blue

Yellow

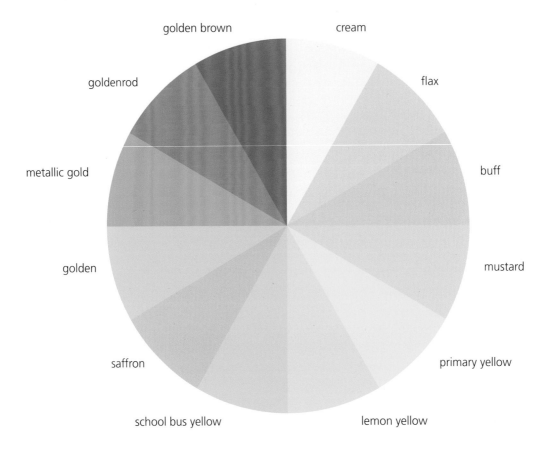

golden brown cream

goldenrod flax

metallic gold buff

golden mustard

saffron primary yellow

school bus yellow lemon yellow

Green

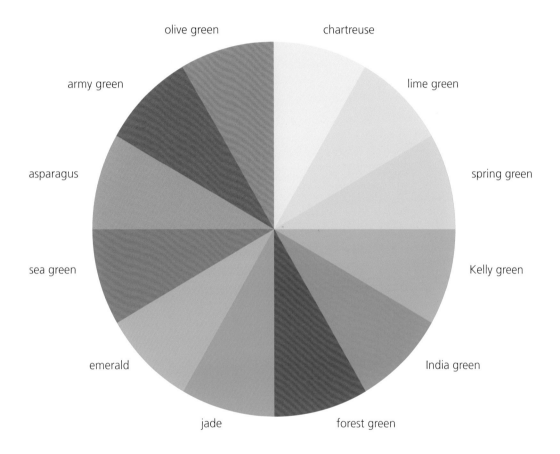

olive green

chartreuse

army green

lime green

asparagus

spring green

sea green

Kelly green

emerald

India green

jade

forest green

Orange

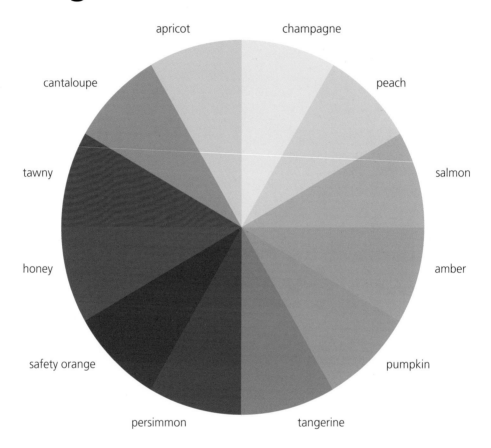

apricot

champagne

cantaloupe

peach

salmon

tawny

honey

amber

safety orange

pumpkin

persimmon

tangerine

Pink

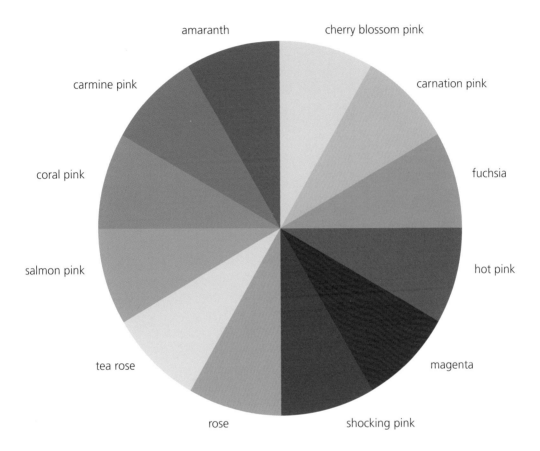

amaranth · cherry blossom pink · carnation pink · fuchsia · hot pink · magenta · shocking pink · rose · tea rose · salmon pink · coral pink · carmine pink

Red

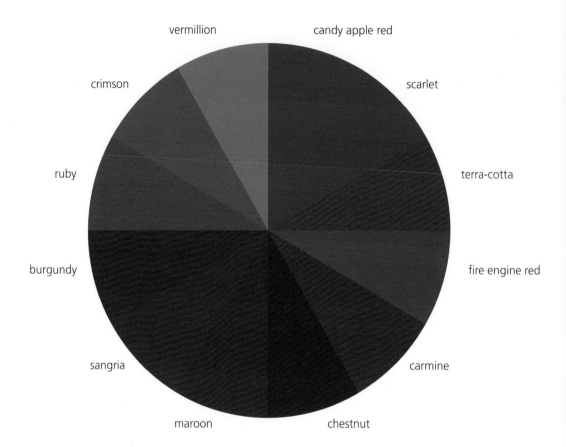

vermillion

candy apple red

crimson

scarlet

ruby

terra-cotta

burgundy

fire engine red

sangria

carmine

maroon

chestnut

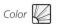

Purple

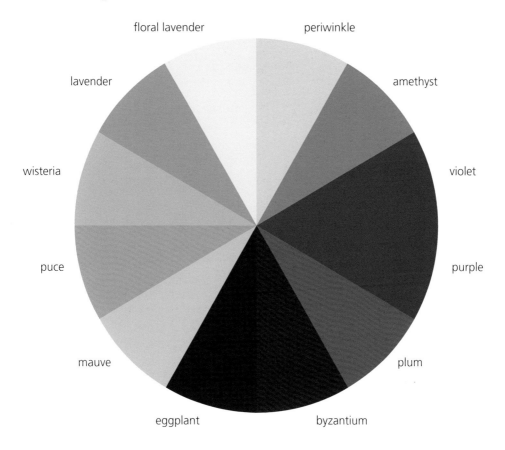

floral lavender periwinkle

lavender amethyst

wisteria violet

puce purple

mauve plum

eggplant byzantium

Gray

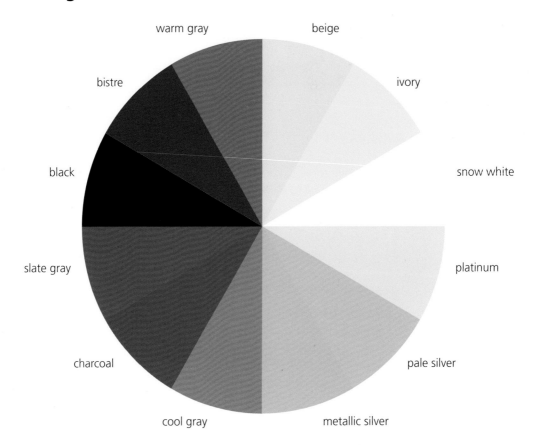

warm gray · beige · bistre · ivory · black · snow white · slate gray · platinum · charcoal · pale silver · cool gray · metallic silver

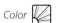

Brown

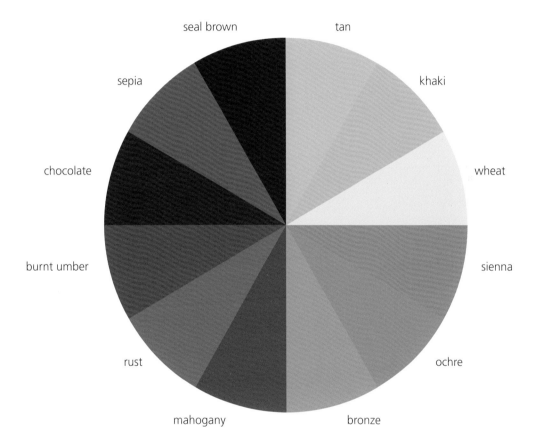

seal brown

tan

sepia

khaki

chocolate

wheat

burnt umber

sienna

rust

ochre

mahogany

bronze

Color Theory

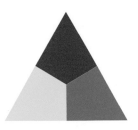

Primary Colors

The three colors in the central equilateral triangle, red, blue, and yellow, are the primary colors. They are called "primary" because they cannot be made by mixing any other colors.

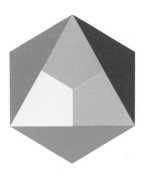

Secondary Colors

The next three colors represented in isosceles triangles, orange, purple, and green, are called "secondary colors." They are made by mixing two primary colors. For example, yellow + blue = green.

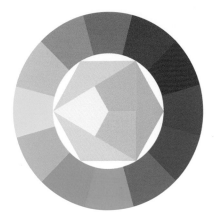

Tertiary Colors

The primary and secondary colors appear again in the outer ring. The colors that appear between the primary and secondary colors are called "tertiary colors." They are the result of mixing primary and secondary colors. For example, yellow + orange = orange-yellow. The six basic tertiary colors are orange-red, orange-yellow, yellow-green, blue-green, blue-purple, and red-purple.

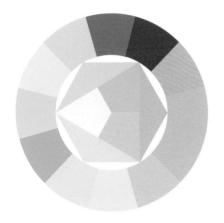

Discordant Colors

When two colors that appear next to each other on the outer ring of the color wheel are used together in a composition, such as red + orange-red or yellow + yellow-green, they are often referred to as being **discordant**, **unbalanced**, or **clashing**. This is because the colors are so similar to each other that they fight for our eye's attention. While terms like *unbalanced* and *clashing* carry the negative connotation of being displeasing to the eye, discordant colors are also often positively described as being **eye-catching** or **dynamic**.

Harmonious Colors

When two colors that appear exactly opposite each other on the outer ring are used together in a composition, such as yellow + purple or orange-red + blue-green, they are often referred to as being **harmonious**, **balanced**, or **complementary**. This is because the colors are so different from each other—exact opposites in their degrees of warmth and coolness—that when they are put together each color makes up for what the other lacks, creating a sense of balance and stability.

Color Format

Achromatic

high-contrast

low-contrast

Monochromatic

sepia tone

blue filter

Polychromatic

Technicolor
saturated

muted
unsaturated

Emotional Response

	Emotion		
	negative	**neutral**	**positive**
light	garish glaring tacky loud	sharp vivid bright	brilliant vibrant lively
Value	dull drab gloomy murky	muted subdued	deep rich sumptuous sensuous
dark			

When we describe the **value** (also called **brightness**, **lightness**, or **tone**) of color, we use adjectives that indicate both how bright the color is and how we feel about the color. For example, if a color is very bright and we love it, we call it **vibrant** or **brilliant**. If it is very **bright** and offensive to our eyes, we call it **glaring** or **garish**. If a color is dark and beautiful, we call it **sumptuous**, but if it is dark and depressing, we call it **gloomy**. Use this chart to find adjectives that describe positive, negative, and neutral emotional responses to light and dark color values.

Warm *Alive and Glowing*

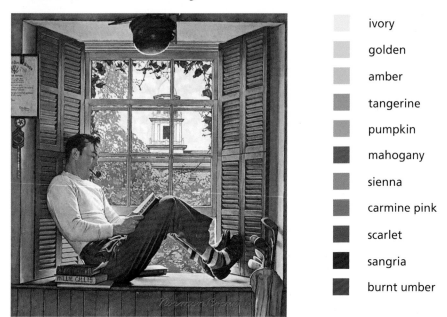

ivory

golden

amber

tangerine

pumpkin

mahogany

sienna

carmine pink

scarlet

sangria

burnt umber

Willie Gillis Goes to College, Norman Rockwell, 1946

Norman Rockwell is famous for painting quintessential scenes of postwar America. To convey a sense of nostalgia and fondness for the American experience, he typically worked with a very **warm** palette, as in this 1946 piece, *Willie Gillis Goes to College*. The subject of this painting is a young man, returned to civilian life after serving in the army and studying under the G.I. bill. His face is **pumpkin orange** and his ruddy cheeks are **carmine pink**, as he puffs contentedly at his pipe. His body and his clothes blend **harmoniously** into the background of woodwork, books, trees, and sky, all crafted together in tones of **ivory**, **sienna**, **mahogany**, and **burnt umber**. The colors and lines are soft and fuzzy, as if the details of the memory are not quite in focus, but the feeling of affection toward that time is unmistakable. The painting projects a warm and unvarying orange glow that creates a timeless effect, as if a pleasant fall afternoon were preserved forever in a drop of **amber**.

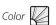

Cool *Cold and Detached*

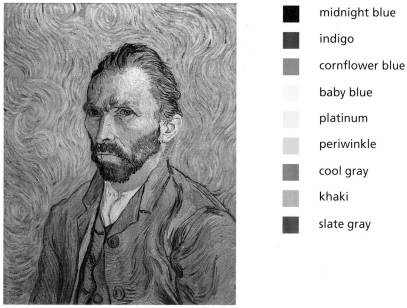

- ■ midnight blue
- ■ indigo
- ■ cornflower blue
- □ baby blue
- □ platinum
- □ periwinkle
- ■ cool gray
- □ khaki
- ■ slate gray

Self-Portrait, Vincent van Gogh, 1890

For this Van Gogh self-portrait, the artist chose to use a cool, **muted** palette of blues, grays, and browns, accented only by a **dull persimmon orange** in the figure's beard. The shape of the man's suit and face are roughly etched into the swirling background in free-flowing lines of **midnight blue**, **black**, and **indigo**. The painting is tinted in such a way that there is very little distinction between the man and his surroundings. In fact, both the figure and the background are so overwhelmingly soaked in a **pale cornflower blue** that the painting is almost a **monochromatic** study of **dull**, cerulean emotion. It's as if the subject's feelings are literally coloring the world around him. These cold, detached colors, combined with the pensive facial expression and penetrating stare, work together to create an overall mood of depression and **gloom**.

Dynamic *Bright and Bold*

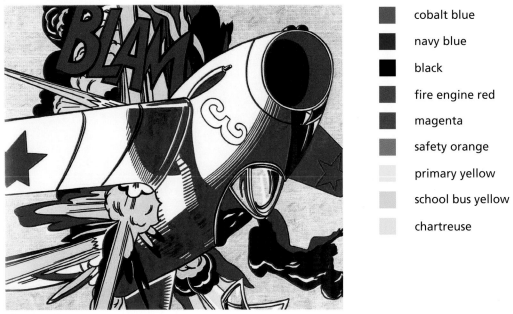

- cobalt blue
- navy blue
- black
- fire engine red
- magenta
- safety orange
- primary yellow
- school bus yellow
- chartreuse

Blam, Roy Lichtenstein, 1962

Roy Lichtenstein modeled this 1962 painting on an image from a comic book. The electric energy of this jet plane explosion is equally matched by the **dynamic** color choices of **lemon yellow**, **fire engine red**, and **cobalt blue**. The rigidly defined black lines that outline the forms work together with these **glaring** colors to make the action jump right off the canvas and into the viewer's face. Lichtenstein's use of **bold primary** colors—red, yellow, and blue—is certainly eye-catching, but it also serves a secondary purpose: These simple colors give the painting a childish, elementary sensibility which underscores the reductionism, or dumbing-down, of pop culture that is associated with the advancement of television and other forms of passive media. This piece can be seen as a commentary on the way that pop imagery placates society, overwhelming our senses and leaving us devoid of human emotion. It is only when we step back for a moment from the intoxicating appeal of this painting's pop-power that we become aware that this is a "fun" and "exciting" image of a man's plane blowing up as he falls to his death.

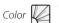

Pastel *Soft and Sweet*

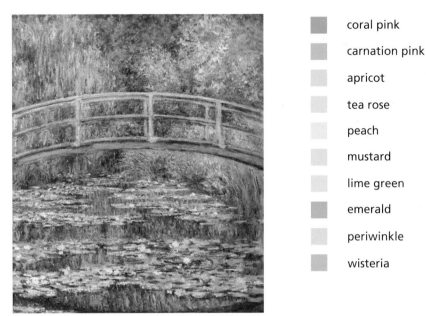

	coral pink
	carnation pink
	apricot
	tea rose
	peach
	mustard
	lime green
	emerald
	periwinkle
	wisteria

Bridge over a Pond of Water Lilies, Claude Monet, 1899

Claude Monet painted this charming scene as an Impressionist representation of one of his own gardens at Giverny, France. He uses a **soft** and subtle combination of **tea rose** and **peach** to capture the flowering lilies, while the surrounding grasses and trees are gracefully rendered with swaying lines of **mustard yellow, pale wisteria,** and **emerald green.** The bridge itself, gently arching over the placid, reflective pond, is depicted in **lavenders** and **periwinkle**, with accents of **carnation** and **cherry blossom pink**. Monet was known for his meticulous landscaping, and his desire to create **harmony** between natural and architectural elements is well-illustrated in his interpretation of this bridge, which looks every bit as floral and serene as the surrounding foliage. Truly, every aspect of this garden scene is conveyed in **complementary pastel** colors, engendering an overall feeling of peace and stillness. It is owing to works like this one that Monet is considered the father of Impressionism, as the lovingly dabbed traces of pigment that compose *Bridge over a Pond of Water Lilies* are meant to communicate a transcendent emotional experience of color and nature, rather than to sharply define and accurately reproduce reality.

Earthy *Hearty and Organic*

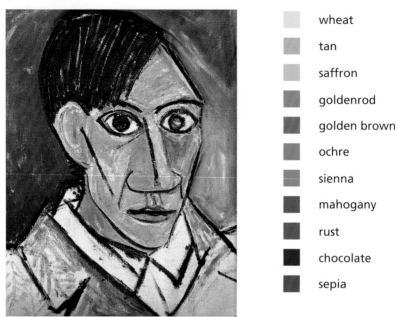

	wheat
	tan
	saffron
	goldenrod
	golden brown
	ochre
	sienna
	mahogany
	rust
	chocolate
	sepia

Self-Portrait, Pablo Picasso, 1907

In this 1907 self-portrait, Pablo Picasso rendered himself as a young man in **warm**, **earthy** tones. The figure's face, carved by **bold**, brown lines, stands out in sharp relief from the background of **ochre** and **mahogany**. The face itself is primarily colored with **soft** pigments of **tan** and **wheat**, but undertones of orange and yellow in the nose, as well as pink in the cheeks, give the figure a robust sense of life and youthful vigor. What is noteworthy from a historical perspective about this piece, painted when Picasso was in his mid-twenties, is the color and style of lines used to create the figure's shape. The **broad** lines used to characterize the hair, eyes, facial features, and cut of the man's suit are all the exact same **chocolate brown** tone, clearly produced by the exact same pigment in various degrees of weight and thickness. This repeated color choice reiterates the simplistic style and economy of lines used to represent physical features, a technique that would become a predominant aspect in the most celebrated works of Picasso's oeuvre.

Luxurious *Deep and Rich*

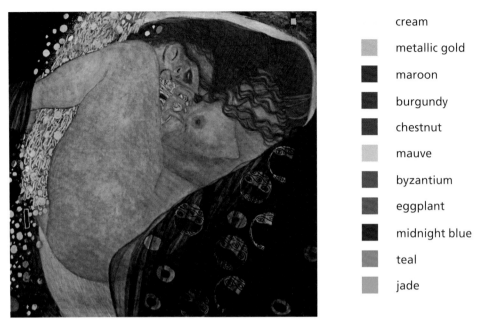

cream

metallic gold

maroon

burgundy

chestnut

mauve

byzantium

eggplant

midnight blue

teal

jade

Danaë, Gustav Klimt, 1907

For this 1907 painting of Danaë, Gustav Klimt selected a **luxurious** and **sensual** palette of colors to create his own highly erotic version of the Greek myth. In the original story, Danaë was locked up in a cave by her father, King Acrisius, who wished to keep her childless, but his plan failed when she was impregnated by the god Zeus, who came to visit her in the form of a golden rain. Klimt captured the ripeness and fertility of Danaë's flesh with a mixture of **rich cream** and **rose** tones layered over a foundation of darker **mauves** and **purples** to express the warm, vital blood that pulses beneath her skin. The golden god that pours between her legs is manifested in shining **ivory** and **saffron** circles and curls of electricity that glow against the **coal black** background. Finally, the entire love scene is wrapped in silk blankets of deepest **byzantium** and **eggplant**. These purple wrappings not only represent her royal lineage, they also suggest the dark warmth of the womb.

Vibrant *Radiant and Energetic*

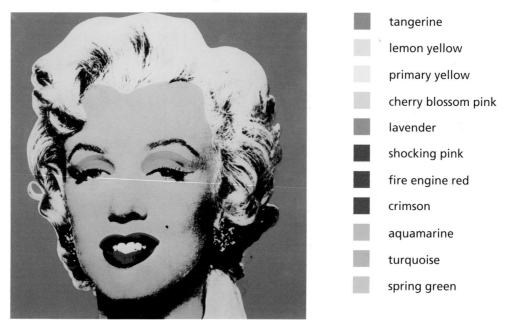

- ▮ tangerine
- ▮ lemon yellow
- ▮ primary yellow
- ▮ cherry blossom pink
- ▮ lavender
- ▮ shocking pink
- ▮ fire engine red
- ▮ crimson
- ▮ aquamarine
- ▮ turquoise
- ▮ spring green

Shot Orange Marilyn, Andy Warhol, 1964

This painting from Andy Warhol's 1964 Marilyn Monroe series pulses with vibrant energy and life. Monroe's **cherry blossom pink** face is ringed by a flame of **lemon yellow** hair, reaching a pinnacle of brightness in the pure **primary yellow** above her left temple, creating an effect not unlike that of staring into the sun. Her **lavender** eye shadow and **crimson** lipstick are applied in broad swaths of pigment, giving her a clown-like appearance. The circus theme is reiterated by a deeply **saturated tangerine orange** background, which cries like a carnival barker for the audience's attention. But for all its sunny **radiance**, this is not a happy painting. The **brilliant** hues of the composition are at odds with the dead eyes and sedated expression of the actress. The result is a disconcerting image that captures the conflict between Monroe's sensationalized public persona and her troubled inner life.

Gloomy *Dark and Dreary*

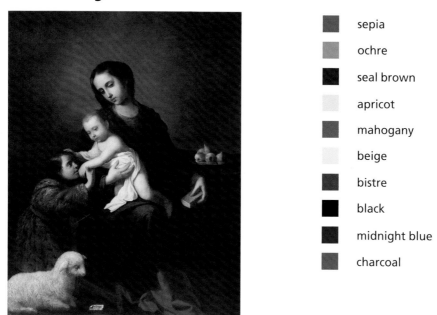

■	sepia
■	ochre
■	seal brown
■	apricot
■	mahogany
■	beige
■	bistre
■	black
■	midnight blue
■	charcoal

Virgin Mary with Child and the Young Saint John the Baptist, Francisco de Zurbarán, 1662

This joyless scene of the virgin with child exemplifies the **gloomy** moods inspired by Francisco de Zurbarán's somber color palette. The child is the focal point, radiating with a light that seems to extinguish almost immediately in the surrounding darkness. Mary's robes are cast in a **midnight blue** fading to **murky black** and trailing down to the floor where a **scarlet** blanket has been desaturated to a lifeless **rusty mahogany**. The young Saint John wears a musty-looking **ochre** fur, and the downward-gazing sheep is rendered in hues of **beige** and **dirty apricot**. The feeling of inescapable despondency is completed by a **sepia** background, darkening into a vignette of **bistre** and **seal brown**. It is commonly thought that this sort of **dreary** Baroque color scheme was intended to communicate the seriousness of religious piety; however, to a modern eye it can seem rather depressing.

Composition

CHAPTER 3

Arranging Space

Composition refers to the way things are put together. In the case of two-dimensional images, it describes the way that different elements are positioned within the frame, with respect to each other and to the viewer, to create a particular impression. The organization of foreground, middle ground, and background; perspective, cropping, movement, and depth; as well as subject placement and body posture, all fall under the umbrella of "composition." Because it is so nuanced and often very subtle, composition is perhaps the most challenging aspect of art and design to talk about, but this analysis can also be the most beneficial for deepening your understanding of form and function.

Organizing the Frame

upper left-hand corner; top left corner	top center	upper right-hand corner; top right corner
in the upper left portion of the frame/image	about a third of the way down from the top of the frame	in the upper right portion of the frame/image
on the left-hand side of the image	just/slightly above the center of the frame	on the right-hand side of the image
slightly/just to the left of the center	in the exact center of the image; in the dead center of the image	slightly/just to the right of the center
on the left side of the frame	just/slightly below the center of the image	on the right side of the frame
in the lower left portion of the frame/image	about a third of the way up from the bottom of the frame	in the lower right portion of the frame/image
bottom/lower left-hand corner; bottom left corner	bottom center	bottom/lower right-hand corner; bottom right corner

Linear Perspective

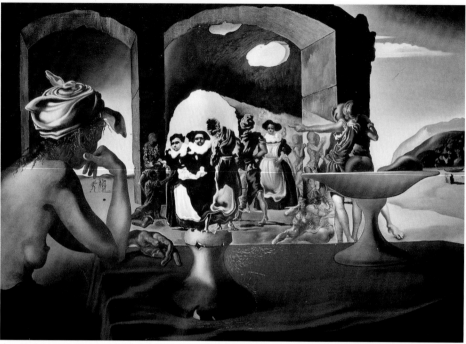

Slave Market with the Disappearing Bust of Voltaire, Salvador Dalí, 1940

Love him or hate him, Salvador Dalí was a genius when it came to composition. Dalí employed rigorously precise perspective techniques to give his surreal images a captivating sense of hyper-reality, as in this 1940 oil painting, *Slave Market with the Disappearing Bust of Voltaire.* The practice of linear perspective, first employed by fifteenth-century Renaissance painters, incorporates a number of strategies that work together to trick the eye into seeing three dimensions on a two-dimensional surface. The following analysis will illustrate the key concepts that make this illusion of depth possible.

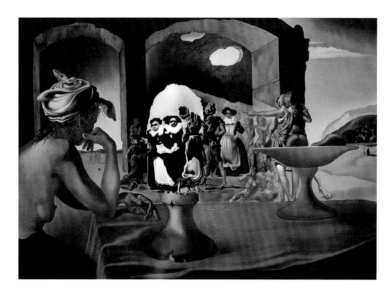

center of focus

focal point

picture plane

optical illusion

1. This painting creates the illusion that the viewer is sitting at the table next to the top-less woman, watching the bizarre scene of human passion and pain unfold before her. The painting has a distinct **center of focus** in the two warped-looking, black-and-white-clad women. This **focal point** is positioned just left of center, presumably because placing the focus in the exact center usually creates a feeling of artificiality or fakeness. Not only does this area of the **picture plane** draw our attention by being the brightest section with the highest contrast, it is also the conceptual center of interest. It is here that we see the **optical illusion** of the painting: These figures are simultaneously a pair of women and also the face of Voltaire. Framed by the head-shaped arch behind them, the women's faces become the two eyes of the bust and our imagination fills in the blanks, finding nose, neck, and mouth in the women's garments.

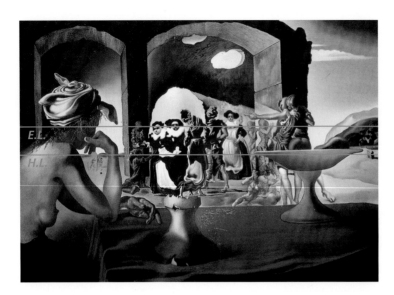

eye level

horizontal axis

horizon line

vanishing point

2. A number of techniques come together to place the viewer of this painting at a specific vantage point. The first is that there is a clear **eye level (E.L.)**. The woman in the foreground's eyes are almost exactly on the same **horizontal axis** as the eyes of the two women in black and white, which are more or less on the same level as the eyes of the smaller figures standing under the archway. This is the same eye level that the viewer feels he or she is on when looking at the image. Other figures' eyes may be somewhat lower or higher, as they are taller, shorter, or perhaps slightly up- or downhill, but nonetheless there is a strong sense of eye level around which everything in the image is based. Additionally there is a clear horizon line, where the hills meet the sky in the distant background. This **horizon line (H.L.)** is just below the eye level line, giving the viewer the impression that he is looking slightly downward on the scene. The point on the horizon line where the viewer's eyes are focused is called the **vanishing point (V.P.)**. In this painting, the vanishing point is located approximately where the shirtless woman's fingers meet the horizon line.

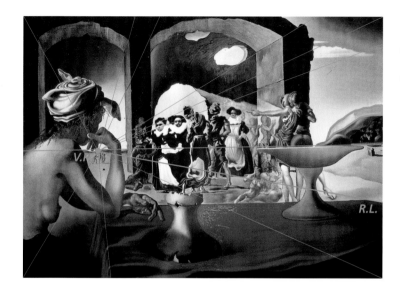

receding lines

converging lines

aerial perspective

3. On close observation, one will notice that all the lines marking the edges of objects like the red table and the stone columns point toward this vanishing point. If they were to continue, these lines, called **receding lines** (**R.L.**), or **converging lines**, would all meet at the vanishing point. All of these careful calculations work together to give the viewer the impression that he is sitting right there, living and breathing, inside Dalí's dream.

4. This image also employs the technique of **aerial perspective**, a term first used by Leonardo da Vinci, which refers to the natural effect that distance has on color. Objects farther in the distance appear to be fainter in color, as seen in the bluish mountains, the objects at the greatest distance from the viewer's vantage point. This subtle touch gives the painting an even greater sense of depth, as if the background truly faded all the way back to an infinitely distant horizon.

Relative Perspective

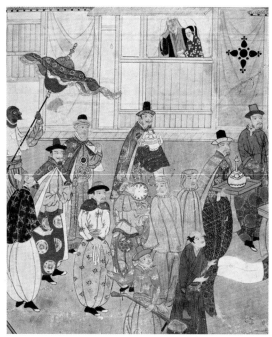

The Landing of the Southern Barbarians, 16th c. Japanese screen

perspective

foreground

middle ground

background

receding

This sixteenth-century Japanese screen has a unique sense of **perspective**. There is a distinct **foreground,** in which merchants and traders are mingling, and a well-defined **background,** in which a man and a woman observe the scene from a window. The elaborately detailed figures in the foreground are certainly larger than those in the background; however, the painting lacks the gradual **receding** of size and line that we find in the mathematical construction of Renaissance perspective. If anything, the musician and silk merchant in the nearest foreground are slightly smaller than the men in the **middle ground**. The overall effect is not one of three-dimensional space, but rather of separate foreground, middle ground, and background planes.

Movement and Depth

concentric circles

focal point

overlapping

layering

depth

movement

Tempo-Tempo, Fortschritt, Kulture (Tempo-Tempo, Progress, Culture),
Marianne Brandt, 1927

This 1927 montage demonstrates several of the modern stylistic two-dimensional graphic design techniques pioneered by Bauhaus designer Marianne Brandt. The image revolves around a powerful but ambiguous machine and the smiling engineer who operates it. Two thin **concentric circles** surround this **focal point**, directing the viewer's attention here immediately. Brandt uses the techniques of **overlapping** and **layering,** as seen in the words radiating out from this center, to create a sense of **depth**. The red lettering is overlapped by the machine, which is in turn overlapped by the white lettering, creating the illusion that some elements are farther away and some are closer. Similar techniques of layering, combined with a sort of aerial perspective, are used to create **movement**. In the upper right portion of the image, lettering is placed on top of, or hidden behind, a vertical black bar, creating the sense that the charcoal gray word "*Kulture*" is moving away into the background, while the bold black word "*Tempo*" is moving outward, toward the viewer.

Narrative in Advertisement

narrative

reference

repetition

reiteration

minimal

sleek

Snow White, Louis Vuitton, 2002

This Louis Vuitton ad uses **narrative** to capture the imagination of consumers. The glossy photograph of a sleeping model **references** the turning point of the Snow White fairy tale—except in this version she carries her apples in a LV handbag. Color **repetition** is key to the success of this image. The shiny sangria-red apples are almost the exact same color as the handbag, linking the bag to the narrative, and connecting it to the symbolic passion and taboo sexuality that the apples represent in the story. This color relationship is reiterated in the apple the model holds in her hand. The red skin of the apple is the color of the handbag and the pure white inside, revealed where she took a bite, references the model's clean white skin and dress. This **reiteration** further connects the apple to the model, the model to the bag, and Louis Vuitton to the fantasy. The text component of the ad is very **minimal**: just some store information and the brand name set in a **sleek** black font against a white background, as if to say, "This is Louis Vuitton; it's beautiful; it's sexy; there's nothing more to say."

Wordplay

Back Cover, Harper's Bazaar, 2002

heading

reverse

superimpose

subheading

wordplay

double meaning

negative space

off-screen

This clever back cover for *Harper's Bazaar* employs several standard techniques of magazine layout composition. The **heading**, "Harper's Bazaar," is written in **reverse** and **superimposed** over the back of the model's head. Slightly below the halfway point of the picture plane is the **subheading** "*Fashion's back!*" This witty little piece of **wordplay** uses the **double meaning** of "back" to express both the idea that fashion has returned (fashion is back) as well as the idea that we are looking at fashion's physical backside. This sentence is the key to understanding the image and must be instantly visible, so the graphic designer superimposed it over the triangular **negative spaces** inside the model's bent arms, allowing the message to stand out against the white background. Finally, the image concept is completed by the addition of hands reaching from **off-screen** to make last minute adjustments to the model, giving the readers a sense that we are getting a behind-the-scenes look at the fashion world.

The Feminine Gaze

clutch

clasp

frontal orientation

on display

gaze over the shoulder

male viewer

peer

Venus with a Mirror, Titian, 1555

Titian's *Venus with a Mirror* is unique among Renaissance nudes for its treatment of the **feminine gaze**. The woman's body language at first seems to follow codified norms of this period. The way that she **clutches** her chest with one bejeweled hand and **clasps** her robe together with the other is mimicked in the posture of thousands of other European nudes. She is portrayed in a **frontal orientation**, with her body **on display** for the viewer as she **gazes over** her **shoulder**. This gentle gaze away from the viewer and toward a mirror, a lover, or simply off into the distance, creates a sense that the female subject is more of an object to be owned and enjoyed than a self-possessed person. She is not interacting with the viewer in any way—in fact, her object-hood is reiterated through her activity: passively observing her own beauty. However, in Titian's composition, the angle of the mirror is such that the gaze of the presumably **male viewer** is met with a single eye, shiny, black, and intense, **peering** directly back at him. Seen in this way, the painting serves as a subtle precursor to the full-on confrontation that would be found in later paintings, such as Manet's *Olympia*.

Inviting Posture

tilted to the side

"come hither"

stiffly

tipped back

parted red lips

hanging loosely

rotated hips

squarely

locked knees

leaning forward

Coca-Cola magazine ads, the Coca-Cola Company, circa 1940s

These World War Two era Coca-Cola illustrations exemplify the way that body posture has been used in advertisement to signify sexual availability and invitation. Notice the way that each young woman's head is slightly **tilted to the side**. This understated posture serves the dual function of directing the viewer's attention toward the raised glass of Coca-Cola while simultaneously suggesting that the woman holding the glass is available and we should **"come hither"** and join her. The redhead in the white uniform stands rather **stiffly**, with her back straight and her hand on her hip; however, her **tipped back** hat and **parted red lips** are indicators of sexual openness. The woman in the blue uniform is more casual, with her arm **hanging loosely** at her side and holding her gloves, a clear signal that work is finished for the day and it's time for pleasure. Unlike the outer women, whose **hips are rotated** a ladylike 30 or 45 degrees away from the viewer, the woman in the center stands with her body facing **squarely** toward us. Her **knees are locked** together and she is **leaning slightly forward**, charming the viewer with the eager, willing playfulness of a child.

Awkward Confusion

wide-eyed

drooping lips

trembling

pigeon-toed

internal rotation

grasping hands

tension

vertical format

Johnny Borrell for British Vogue, Mario Testino, 2007

In this portrait of Johnny Borrell, Italian fashion photographer Mario Testino perfectly captures the insecurity and confusion of the male model. Borrell gazes **wide-eyed** up at the camera, his lower **lip drooping** and almost visibly **trembling**, his teeth lightly parted. He stands **pigeon-toed**, curving his legs in an **internal rotation**, a posture that suggests self-protection and fear. The **hands grasp** awkwardly at nothing, as if he doesn't know what to do with them. Taken from slightly above, the camera looks down upon the subject, intensifying the impression of childishness in the model's posture. There is a discernable **tension** between the **vertical format** of the image, so often used to emphasize a model's height and stature, contrasted against his partial nudity and vulnerability, a poignant representation of a subject uncomfortable in his own body.

Moody Intensity

profile

hunching

folded Arms

glaring

tilted chin

pouting lips

glowering

piercing

challenge

Marlon Brando, Cecil Beaton, 1947

This 1947 **profile** of Marlon Brando captures the depth and intensity of the actor as a young man. Brando **hunches** his spine, **arms folded** over the back of a chair, **glaring** at the viewer as if he were irritated at being interrupted from his reading. His shoulders creep up around his ears, indicating the actor's desire to make a turtle-like retreat into the shell of his oversized suit. His **chin is slightly tilted** downward and his **pouting lips** hint at a deep, hidden sensitivity. But it is the eyes—**glowering**, **piercing**, burning a hole directly through the viewer's soul—that hold the power of this photograph. Even in this frozen, timeless medium, Brando offers a visceral **challenge** to the viewer, asking each and every one of us a question: Are you capable of returning this stare?

CHAPTER 4

Material

Surface and Structure

A crucial step in every creative process is the choice of material. Material not only affects the aesthetic and physical construction of an object, it also has the power to change the symbolic meaning of a piece. Every creative field, from oil painting to interior decorating, has its own specialized set of materials, and learning how to work with these materials is a fundamental aspect of art and design education. This chapter offers the essential vocabulary needed to call materials by their proper names, as well as adjectives to describe their physical nature, their surface texture, and their state of being, from shiny and pristine to rusty and tarnished.

Hardness and Flexibility

hard	pliable
rigid	pliant
stiff	bendable
firm	flexible
supple	stretchable
soft	elastic

Surface Texture

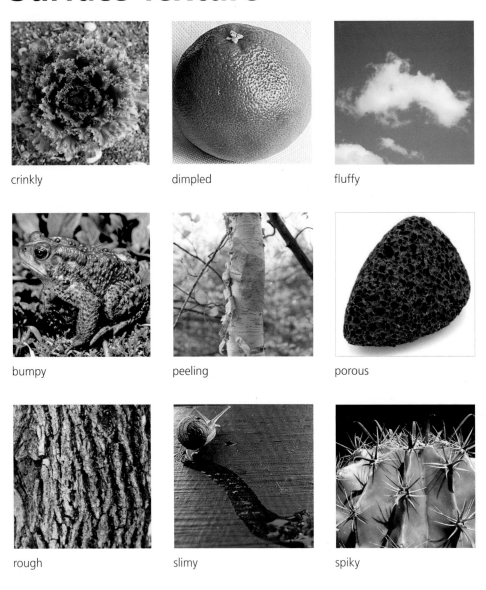

crinkly

dimpled

fluffy

bumpy

peeling

porous

rough

slimy

spiky

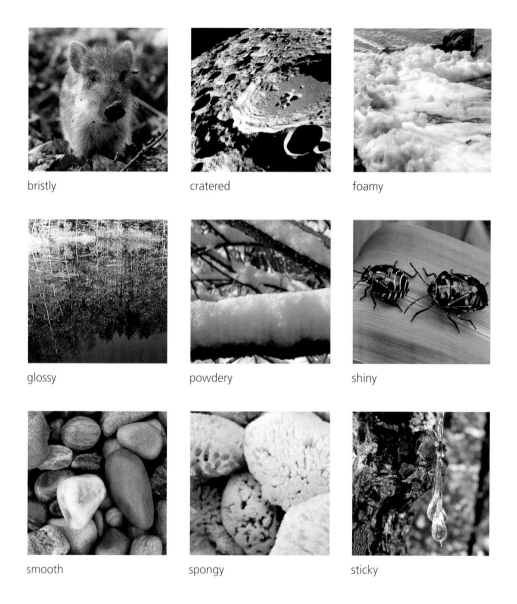

bristly

cratered

foamy

glossy

powdery

shiny

smooth

spongy

sticky

Glass

broken mirror

etched glass

glass blocks

hand-blown glass

neon glass tubes

plate glass

reinforced glass

shattered glass

stained glass

Wood

bark

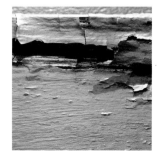

chipped paint

corrugated cardboard

etched presswood

lattice fence

plywood

rotten wood

wicker basket

wood chips

Metal

aluminum

barbed wire fence

brass

chicken wire

corroded wrought iron

diamond grate

mangled chain-link fence

oxidized steel chain

steel screws

Stone

asphalt

bathroom tile with grout

bricks and mortar

cinder block

cobblestones

cracked pavement

marble column

mosaic

pebbles

Plastic

Bubble Wrap

foam board

Formica

nylon twine

Plexiglas

polyethylene

rubber handle

shrink wrap

Styrofoam

Organic

jute burlap

cotton yarn

raw cotton

raw sheep wool

silk chiffon

twine

twisted hemp rope

wool yarn

woven straw

Modern Materials

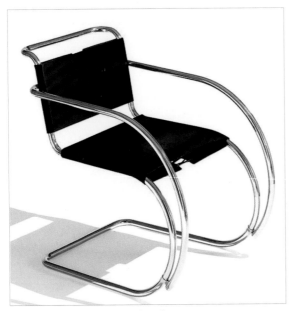

functionalist

chrome-plated

tubular steel

malleable

taut

airy

industrial

Weissenhof Chair, Ludwig Mies van der Rohe, 1927

The *Weissenhof Chair*, designed for the Bauhaus by Ludwig Mies van der Rohe, is a study in **functionalist** form. The frame is constructed from a single continuous tube of **chrome-plated tubular steel,** and another stretch of this **malleable** material is wrapped around the back of the chair to form two curvilinear arms. The seat and backrest are constructed from two broad strips of leather, stretched **taut** over the frame and stitched together with sturdy cord. The **airy** form of the chair clearly reveals every detail of its design, hiding nothing, proudly displaying the **industrial** strength and elegance of its materials.

Postmodern Polymers

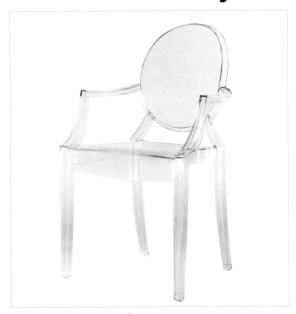

Louis Ghost Chair, Philippe Starck, 2002

transparent

injection-molded

polycarbonate

durable

infinitely reproducible

adaptive

The *Louis Ghost Chair*, designed by Philippe Starck in 2002, is a **transparent** reinterpretation of a chair popular in the eighteenth-century court of Louis XV. Starck's version is made from **injection-molded polycarbonate**, shown here in dusty rose. This **durable** chair takes the functionalist idea of self-expressive design a step further; its see-through material is literally incapable of hiding anything. Modeled after a chair that would have been handmade by the finest craftsmen in France three hundred years ago, this computer-generated, **infinitely reproducible** object is something that no one today could conceive of making with their own two hands. Plastic is the material of the postmodern thinker, as changeable and **adaptive** as thought itself.

Synthetic Armor

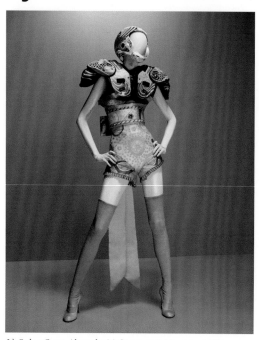

rigid

fiberglass

acrylic

delicate

fragility

diaphanous

silk

chiffon

synthetic

It's Only a Game, Alexander McQueen, spring/summer 2005

This ensemble from Alexander McQueen's spring/summer 2005 collection invokes a virtual world of fantastic avatars, a space of imagination far beyond the limitations of the mundane earthly realm that we inhabit. The playful appeal of the look lies in the dynamic tension between **rigid** and supple materials. The **fiberglass** shoulder pads and helmet, emboldened by **acrylic** war paint, are juxtaposed against the delicate **fragility** of the **diaphanous** lavender leggings and undergarments of **silk** and **chiffon**. The defiant pose of the mannequin only adds to the empowering fantasy of a willful princess, proudly displaying her **synthetic** superhero armor.

Organic Oddity

tactile

sprout

mimicking

speckled

spiny

bristles

Soundsuit, Nick Cave, 2010
Courtesy: Mary Boone Gallery and Jack Shainman Gallery, New York.

Soundsuit, created by artist and performer Nick Cave, is a wearable sculpture that explores the **tactile** and visual possibilities of organic materials. The dogwood twigs that **sprout** from the "skin" of the costume create a luxurious and dynamic color palette. The rich burgundy bark glows brightly where it is exposed to the light, but then gradually darkens to a deep purplish-chestnut in the dense folds, **mimicking** the appearance of animal fur. The effect is completed by the white accents that appear where the twigs have been cut, giving the surface a **speckled** pattern like the coat of some unknown mammal. This **spiny** mock-fur **bristles** with vital porcupine energy, simultaneously defending against attackers and attracting our eye to its natural beauty.

Miniaturization

miniaturization

spatial perspective

extreme close-up

glistening

itty-bitty

Lilliputian

absurdity

Egg Crack Crew, Christopher Boffoli, 2007

Miniaturization of the human form is often employed to humorous effect, as in this Christopher Boffoli photograph of a pair of tiny maintenance men inspecting the damage to the cracked shell of an egg. The image disrupts our ordinary sense of **spatial perspective** by presenting us with an **extreme close-up** of the **glistening** surface of a common hen's egg. We as viewers must momentarily laugh at ourselves as we share a ridiculous desire to lean over one of the men's shoulders to get a peek at whatever's down there. Standing in their serious poses as their **itty-bitty,** candy-striped orange safety cone threatens to slide down the hill, these **Lilliputian** figures underscore the inherent **absurdity** of our daily occupations.

Oversized

Maman, Louise Bourgeois, 1999

bronze

magnified

monumental

sinewy

marble

enormous

Louise Bourgeois' sculpture *Maman*, cast in **bronze** and standing nine meters tall, has been exhibited in public settings around the world. In this piece, Bourgeois has **magnified** the common daddy longlegs spider so that its physical size reflects our **monumental** psychological fear of the arachnid. Throughout history, the spider has appeared in mythology as a symbol of the all-consuming and terrible mother, and Bourgeois' *Maman* (French for "mother"), with its **sinewy** metal limbs and drooping sack of **marble** eggs, has updated the archetype for the age of postindustrial anxiety. The placement of the sculpture in this sunny plaza makes the impression all the more unsettling, as though an **enormous** monster has escaped from a child's nightmare and is now running loose in small-town Canada.

Stone Arches

durability

rough-cut

interlocking

granite

pillars

tiers

arches

unmortared

Aqueduct of Segovia, Spain, Roman, first century A.D.
Photo: Nicolas Perez, September 2004

A monument to the **durability** of Roman engineering, the Aqueduct of Segovia, constructed in the late first century A.D. to transport water to the city from a nearby river, still stands in near perfect condition today. This view from below highlights the simple elegance and strength of the design. **Rough-cut interlocking granite** bricks are stacked into a series of **pillars** that support two **tiers** of **arches**, which, in turn, support the water channel. The bricks of the aqueduct are **unmortared**, relying on a precisely balanced arrangement and the force of gravity to remain erect. The final result is an open and airy structure that emphasizes the strength of its materials and the sophistication of its function, not unlike the designs of the modernist revolution nearly two millennia later.

Translucent Skin

hybrid

polymer

translucent

skin

channel glass

semitransparent

opaque

Central Wing Extension to Higgins Hall, Pratt Institute School of Architecture, Steven Holl, 2005

Designed by architect Steven Holl, the 2005 Central Wing Extension to Higgins Hall at Pratt Institute's School of Architecture demonstrates the multifunctionality of a **hybrid polymer** and glass building material. The **translucent** skin of the building is constructed from thick slabs of **channel glass** filled with a synthetic white insulation. During the daytime, the **semitransparent** skin lets in a diffuse glow of natural light, while remaining **opaque** enough to protect the privacy of the students working inside. At night, the building glows from within, providing a safe and inviting destination for students walking through Pratt's urban Brooklyn neighborhood.

Formal Analysis

CHAPTER 5

What Is Formal Analysis?

Formal analysis is the written or spoken process of examining what your brain does automatically when you see a painting, a photograph, a sculpture, or a design. You have an immediate reaction. Typically, this reaction first voices itself in your head as "I like it" or "I don't like it." But before that happens, the eye makes hundreds of observations, scanning the entire image and noting all of its various details. The brain processes all of this information, taking note of the colors, lines, materials, and composition, and then compares it against everything else you have ever seen. All this takes place in less than a second; your brain then formulates an opinion and sends a signal to your mouth to say, "That's cool," or "That sucks." Conscious formal analysis is the process of slowing down what the brain does at the speed of light to the speed of observation, reflection, and communication. We look closely at an object, without jumping to any conclusions, and explore details and hidden meanings that may otherwise have eluded us.

What Is the Purpose?

Learning how to perform in-depth formal analysis is beneficial to students of art and design for three main reasons:

1. When we first see a piece of art or design, the mind's typical process is to make rapid observations and then quickly formulate a positive or negative opinion. Simply put, the human mind prefers to be lazy and take the easy way out, comparing everything we see to what we have seen before and forming our opinions out of habit. We don't give things a chance to fully reveal themselves to us. However, with the careful, thorough, and studious observation of formal analysis, we are able to see things objectively, as they actually are, rather than relying on preconceived opinions. When we slow down our thinking, we can begin to deconstruct what we see into its component parts and come to understand how each aspect contributes to the whole. In this way we are able not only to fully comprehend how something was made, but also to see how our minds function and how our opinions, our individual likes and dislikes, come into existence. We begin to see objects in their completeness, and our way of experiencing the world around us evolves so that we are operating on a higher plane.

2. Formal analysis expands our potential for creativity. If we want to create anything new, we cannot fall back on old habits; we must understand what others have done and why they have done it before we can make a real contribution. Only by acquiring the ability to understand the relationship between form and function can we begin to make conscious choices and truly develop our own creativity.

3. The last reason to develop a capacity for formal analysis is a matter of pure practicality. We live and work in a community. Great pieces of art and design are rarely created by individuals in complete isolation, and even if they are, the artist must interact in some way with the public. By engaging in formal analysis we can dramatically improve our ability to talk about our work. We have to know how to describe what we have made and defend our choices.

Snapshots

Whenever you introduce a piece that you will be analyzing, you should begin with a snapshot. A snapshot is a single sentence that describes exactly what we are looking at as clearly and concisely as possible. This is essential in formal analysis writing because it grounds us in the object in question while minimizing confusion. Don't describe the color of the eyes, the number of legs, the pattern of the coat, and the texture of the fur before telling the reader that we are looking at a dog.

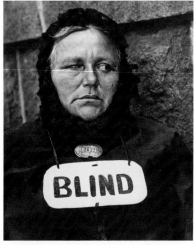

Blind Woman, Paul Strand, 1916

When an image features a human subject, indicate who the subject is, where he or she is, and what he or she is doing. If possible, include some sense of the composition and how the subject is, or is not, relating to the viewer.

Snapshot: This gritty black-and-white photograph is a closely cropped portrait of the head and upper torso of a middle-aged woman standing in front of a stone wall, gazing to the side, and wearing a sign around her neck that reads: BLIND.

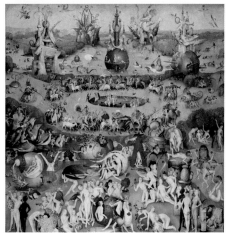

The Garden of Earthly Delights, central panel of triptych, Hieronymus Bosch, 1510–1515

In a crowded or busy scene, try to give a general sense of the aesthetic, action, and environment, without going into specific details.

Snapshot: The central panel of Hieronymus Bosch's *The Garden of Earthly Delights* depicts a phantasmagorical, pastel wonderland, crowded with exotic creatures and people bathing, eating, dancing, and playing together on a broad expanse of vibrant green landscape.

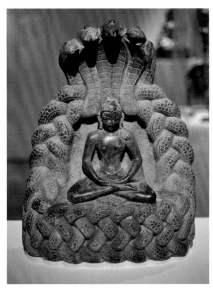

With an artifact from art history, indicate the subject matter as well as the size, material, and physical condition of the object.

Snapshot: Standing about two feet high, this eleventh-century Nepalese statue of the Buddha seated on a protective throne of interwoven serpents was chiseled from a single stone and, aside from some worn-down surfaces, remains today in near perfect condition.

Buddha Sheltered by the Serpent King Muchalinda, Nepal, eleventh century. Photo: Stephanie Simos

For a designed object, describe the form, including the materials and precise measurements.

Snapshot: This clear-coated oak Muji shelving unit is composed of twenty-five identical sixteen-square-inch cubbies, organized into a five by five grid with an external dimension of eighty square inches and a depth of twelve inches.

Stacking Oak Shelf, Muji, 2009

Observation
Subjective Reaction

The first stage of formal analysis is a calm and patient period of studious observation. Begin by taking in the piece as a whole and making a mental note of any emotions or sensations that arise. Does the piece make you feel excited, frightened, melancholy, bored, angry, self-righteous, joyful? This is your subjective reaction. It is important, but it is not the ending point. Make a note of it and then try to put it aside for later.

Form: Dominant colors are bright yellow and reddish-orange.

Function: These colors are discordant and energetic; they create a sense of tension and heat.

Yellow with Red Triangle, Ellsworth Kelly, 1973. Corcoran Gallery of Art, Washington, DC. 1977.17 © Ellsworth Kelly

Form and Function

The next step is to break the piece into its component parts. Spend some time considering the choices that were made in terms of **color**, **line**, **material**, **composition**, **size/scale,** and **context**.[1] For each element, begin by making notes about the form and then contemplate what the function of each formal detail might be. At their most basic, form asks, "What is there?" and function asks, "What does it do?"

Meaning

As you begin to develop a theory about what the piece means, you can relate each form and function pairing to what will become your argument. For example: The presentation of sharp-edged geometric shapes in hot, vibrant colors aggressively asserts the power that minimalist composition holds over the viewer.

[1] **Context** refers to when, where, and how a piece is presented. Ellsworth Kelly's *Yellow with Red Triangle* has a very different meaning when it is mounted on a gallery wall than it would in a corporate lobby.

It is helpful to use a chart to organize your observations.

Form	Function
Line:	
Color:	
Composition:	
Size/Scale:	
Material:	
Context:	

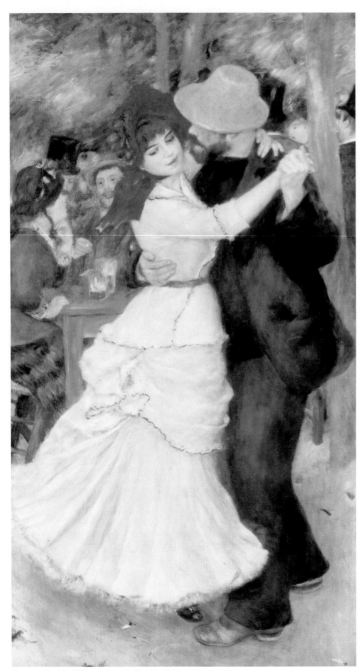

Dance at Bougival, Pierre-Auguste Renoir, 1882–1883

Form	Function
Line: soft, broad brushstrokes	-soft focus of a memory; conveys experience rather than precise reproduction of physical space
-blended lines, blurred, no sharp definition	-approximates motion and mood
Color: black/navy blue suit coupled with cream/tea rose pink dress	-balance of male and female energy, like a yin-yang
-scarlet red hat next to saffron golden yellow hat	-energetic, dynamic, excitement around the couple's heads; focal point
Palette: earthy/pastel	-expresses nature and human emotion
Background: unsaturated tan, ochre, sepia, baby blue, cornflower blue, navy blue, lavender, peri-winkle, kelly green, chartreuse, mustard yellow, cherry blossom pink, tawny orange, burnt umber	-subtly complements the couple, does not fight for attention; fact that background has same color saturation as couple makes for a completely uniform scene with little contrast between couple and environment; couple is part of environment
Composition: couple dominates frame; slightly to the right of center; focal point is woman's face in top third of frame	-couple is the undeniable focus; positioning slightly to right side feels natural, not staged, and creates window to background activity
-figures gaze toward each other and down at the ground	-viewer is a voyeur, not a participant; subjects are unaware of us as we watch them; like reading a story with an omniscient narrator
Size/Scale: 70 ⅝ x 37 ¾ inches	-painting is about as tall as a person, large enough to make a strong impression, but intimate enough for a very human experience
-subjects are approximately 4–4 ½ feet tall; about three-quarters scale to human size	-we feel we are peering into a slightly smaller world than our own; something not quite touch-able
Material: oil on canvas	-oil allows for naturalistic luster, reflective, shiny quality notable in the woman's face and man's suit; oil paint is good for blending pigments to create soft focus and blurred transitions
Context: museum, traveling around world; prominently positioned in Renoir exhibitions	-piece is considered to be a great work of Im-pressionism and one of Renoir's most important paintings

Organization
From Large to Small

Once you have finished recording your observations, you will need to think about how to organize your ideas into paragraphs and ultimately into an essay. A good rule of thumb is to always go from large to small. Another way of saying this is to always move from the general to the specific. Begin with the details that you find most obvious and striking and then gradually zoom in on more nuanced, subtle observations.

For Renoir's *Dance at Bougival*, begin by talking about how the dancing couple is the primary subject of the scene and the way that the composition reinforces their importance. Then focus on color and describe the overall color palette before zooming in on specific details like the hue of the man's beard or the scarlet trim on the woman's dress. After exploring color you can begin to examine more subtle details like the way that the soft lines create a blurry, undefined feeling throughout the piece. Save less prominent details like the expressions and activities of people in the background for last.

Single Paragraph Analysis

If your formal analysis is intended be just one paragraph within a larger essay, begin that paragraph with a snapshot and then focus on whichever details are most relevant to your overall discussion. Discuss line, color, composition, material, etc., only insofar as they are important to the subject of your paper.

Structuring the Essay

If you are writing an entire essay based on the analysis of a single piece of art or design, a very useful organizational strategy is to designate one paragraph for each aspect you will be discussing: one paragraph for color, another for line, another for material, etc. If you are writing a compare and contrast essay about more than one piece, this can still be an excellent method of organization—comparing color in one paragraph, composition in the next, and so on. Remember to begin with large, general topics before proceeding to smaller, more specific ones. The order of the paragraphs will vary in different essays depending on which formal elements are most important for your subject. Here is a sample outline:

Paragraph 1: Introduction
Snapshot
Thesis

Paragraph 2: Subject matter
Composition
Size/Scale

Paragraph 3: Color
Color palette
Specific color details

Paragraph 4: Line
Brushstrokes
Shape and angle

Paragraph 5: Material
Aesthetic
Connotation

Paragraph 6: Conclusion
Significance

Note that after zooming in as far as possible to examine specific details, one should zoom back out in the conclusion to consider why the piece matters within a broader context.

Meaning

Tone of Voice

When you are writing a formal analysis, you are uncovering connections between form and function, and through this process you are generating meaning. When you indicate the significance of various details to the reader, don't overuse words like "means" and "shows." There are many wonderful verbs in the English language which can be used to communicate a wide range of moods as well as meanings. Instead of "means" and "shows," give some of these a try:

Gentle	Forceful
expresses	proves
suggests	proclaims
indicates	exposes
implies	signifies
imparts	symbolizes
illustrates	represents
alludes to	references
hints at	reiterates
conveys	denotes
carries	connotes
communicates	exemplifies
reminds	epitomizes

Examples:

The dove in the foreground of the painting **symbolizes** peace.

The human skull on the table next to the monk **represents** death.

The pale blue background **conveys** a sense of melancholy.

The bold, black lettering against a clean, white background **epitomize**s the modern aesthetic.

The expanding sweat rings in each of his armpits **indicate** that he is quite nervous.

The piercing intensity of the subject's eyes **exposes** his inner turmoil.

The downward strokes of rusty orange and tawny brown pigment **suggest** the falling leaves of autumn.

The unnatural red of the model's lips **denotes** that she has applied a heavy layer of lipstick.

In Chinese cultures, the color red typically **connotes** luck.

The lion skin hanging above the mantle **alludes to** the myth of Hercules.

The rising sun behind the weary soldiers **hints at** the possibility of redemption.

The wildly splattered brushstrokes **reference** the action painting of Jackson Pollock.

The rigid straight lines of the structure **proclaim** the power of minimalist geometry.

The circle **signifies** the feminine.

The soft organic lines of the chair **carry** a more humanistic design philosophy.

The luscious pink and red flowers **imply** the blossoming of womanhood.

Her sullen eyes **communicate** a deep dissatisfaction with her role in life.

The whimsical, flowing brushstrokes **impart** a feeling of joyful elation.

Formal Analysis Essay
Dance at Bougival: The Enchanting World of Renoir

Painted between 1882 and 1883, *Dance at Bougival* is one of the crowning achievements of Impressionist Pierre-Auguste Renoir's career. The piece exemplifies Renoir's brilliance as a master of mood, deftly blending color and composition to engender not only an image, but an experience of human emotion. The subject of the painting is a man and a woman, dancing in a gentle embrace at an outdoor celebration. Although the interplay of tension and intimacy between the male and female subjects is captivating in itself, what is most remarkable about the piece is the way that Renoir's delicate brush has rendered the couple as an inseparable part of the scene, seamlessly woven into their environment, vibrantly alive, eternally present in this moment.

Dance at Bougival glows with a soft and earthy pastel color palette. The dancing couple is awash in a sea of unsaturated hues; Kelly green, chartreuse, and mustard yellow brushstrokes mingle overhead with touches of baby blue and lavender, while streaks of tan and ochre scurry below. The couple themselves, who are positioned in the foreground and dominate nearly three-quarters of the frame, stand out because of the color of their clothing. The woman's dress is a creamy tea-rose pink and the man's suit is a blend of rich navy blue and charcoal. The two complement each other like the halves of a yin-yang, a perfect balance of male and female energy. However, unlike the yin-yang symbol, which is commonly depicted in harshly contrasting black and white, this couple is rendered in softer, more ambiguous tones that seem to flow into each other and melt into their surroundings. The one element that clashes with the easy harmony of the scene is the couple's headwear. Her scarlet red bonnet collides with his saffron golden yellow hat to create an energetic focal point in the upper portion of the frame. Our eye is drawn again and again to the dynamic excitement that these primary colors elicit around the couple's heads as the man leans in to steal a kiss, and the woman looks demurely away.

Along with the soft and sweet colors, Renoir's treatment of line enhances the emotional impact of the piece. Unlike the rigidly defined lines that had been used for centuries in European oil painting to construct a convincing illusion of reality, Renoir's lines are smudged and blurry. Around the border of the woman's dress there is a shim-

mer of pale blue, approximating the movement of dance. The couple's hands come to-
gether in a gentle melding of pigment. It is difficult to see exactly where one ends and
the other begins. The figures in the background are rendered with broad brushstrokes;
a few pink blotches convey rosy cheeks and a couple of brown smudges form a jacket.
Meanwhile, the trees sway above the scene, blending into the sky as green and blue
swipes of pigment overlap and are layered on top of each other. It would seem that
the goal was not so much to create an accurate representation of physical reality, but
rather to paint with the fuzzy focus of a memory.

 Despite Renoir's deliberate fabrication of an unrealistic vision, there is a
certain "realness" to the characters that is made possible because of the quality of the
material itself: oil paint. The oil in the paint imbues the image with a lustrous shine,
reflecting light in much the same way that material objects reflect light in the physical
world. The woman's face, although depicted with idealized simplicity, glows with real
life. The man's yellow straw hat is painted with obviously visible brushstrokes—noth-
ing like the sharp reality of a photograph—yet where the brim catches the light of
the sun, it shines just like a real hat. It is in this odd double vision that we discover
the magic of Renoir's paintings. This lovely little scene is not, never was, and never
will be. And yet here it is before us. The real emotional connection we feel with these
colorful characters belies the fact that they do not exist. The image Renoir has painted
resonates in our minds in much the same way our thoughts, emotions, dreams, and
memories do, so real to us and yet so intangible.

 With its delicately balanced colors and gently caressing lines, *Dance at
Bougival* offers a vision of pleasure that entices and invites the viewer. We long to cast
away the dull shackles of our lives and join the party, to give up everything for just
one merry drink at the table, just one dance, just one kiss. Even the size of the paint-
ing intensifies our yearning to fulfill this impossible desire. With a vertical dimension
of just under six feet, the dancing figures stand about four and a half feet tall, three-
quarters human size. The scale is somehow distancing. We feel as though we are peer-
ing into a wonderfully vibrant world that is slightly smaller than our own. The effect
is whimsical and somehow melancholy—a longing for a beautiful moment that will
exist forever just outside of our reach.

Trend Research Essay: Outline

Introduction

55-Minute Retro-Timer, Dulton Co., Ltd., 2010

- Introduce trend of modern kitchenware with a retro look
- Compare to other trends: efficiency, convenience, like microwave
- Mention materials: silicone, Teflon, stainless steel

Thesis: *Retro-modern kitchenware products attempt to find their way into the hearts and homes of consumers by giving technologically advanced twenty-first-century materials a mid-twentieth-century makeover.*

Body Paragraph 1: Timer

- Introduce first product: Dulton Company's 55-Minute Retro-Timer
- Formal Analysis of product's appearance and function
- **Transition to color:** Minty, emerald green. Explain why this color is the selling point, appealing to consumer's feelings of nostalgia

Body Paragraph 2: Pan

- Introduce second product: Bialetti 10-inch Nonstick Frying Pan
- **Formal Analysis:** Materials: Teflon, steel. Line: Art-Deco handle. Color: banana yellow opposite of sleek black Teflon pans from 1990s
- **Transition:** Ornamental details are functional, but also try to appeal to consumers who want old-fashioned, classic look

Body Paragraph 3: Spoon

- Introduce third product: Tovolo Silicone Mixing Spoon
 Quote: George Marcus: *"simple, honest, direct . . . expressive of material"*
- Demonstrate how the company tries to promote the greatness of the design and material by quoting text from the packaging
- Contrast modern, functional marketing with strawberry pink color choice
- Show that company is trying to appeal to intellect and emotion

Conclusion

- Present theory on reason for this trend: new generation of young professionals

Trend Research Essay
Retro-Modern Kitchenware

In today's fast-paced consumer society, kitchenware designers are working overtime to develop products that will motivate customers to actually spend the time to cook a good, old-fashioned meal. While some branches of the industry have followed in the footsteps of the microwave, focusing on designing products that increase cooking convenience and efficiency, other companies have hedged their bets on appealing to consumers' emotions, namely their nostalgia for a simpler time of warm chocolate chip cookies at Grandma's house and chicken dinners on Sundays. A visit to any one of the hip kitchenware stores that have sprouted up all over America's metropolitan areas will reveal a distinct trend toward retro aesthetics. What is fascinating about this trend from a design history point of view is the way in which products manufactured from cutting-edge contemporary materials like silicone and Teflon mask their "newness" behind curvilinear Art-Deco design and retro-pastel colors that harken back to the 1950s. Let's take a closer look at a few products that attempt to find their way into the hearts and homes of consumers by giving highly functional twenty-first-century materials a mid-twentieth-century makeover.

The first product that caught my eye when I walked into Whisk, a high-end kitchenware boutique in Williamsburg, Brooklyn, was the Dulton Company's 55-Minute Retro-Timer. The timer is about the size of a hockey puck, with a disk-shaped face, and is composed of a stainless steel ring with a Plexiglas cover and set on a flattened, semispherical base. The base is made of color-coated steel and shaped a bit like an antique fire alarm. Beneath the Plexiglas cover is the user interface, which has a cream background and the words "Round Timer" written in an antique, red font, and the trademark "DULTON CO., LTD." written in black. There is a red steel indicator needle and the numbers zero through fifty-five are spaced evenly by fives around the perimeter. To set the timer, one just has to twist the steel ring clockwise—although the Whisk salesman did have to explain to me that you must twist the needle all the way to the 55 mark before setting it to your desired time because the timer was, in his words, "old-fashioned." When the timer goes off it emits a loud, jarring ring as an actual steel hammer beats on an actual steel bell inside the timer's body, producing a

satisfyingly analog sound in an increasingly digital world. One final functional element is the strong magnet on the back of the timer, which allows it to be affixed to a stove or refrigerator. But the functionality of the product was not what attracted me; I was sold on the color.

The Retro-Timer came in three different shades. There was a mustard yellow and a candy apple red, but the one that came home with me was the green. It wasn't just any green; it was a creamy, minty, emerald green; 1965 Buick green; the exact same green as my grandmother's toaster oven. Like most modern city dwellers, I don't bake, and if I did bake I would probably try to use my cell phone as a timer, and I would probably get distracted texting or playing Ms. Pac-Man and end up burning the brownies. Whether or not this new kitchen timer will inspire me to bake more often or with more success remains to be seen, but the 55-Minute Retro-Timer did its job of convincing me to pay $10 plus tax to have it on my fridge.

The next product to attempt to seduce me into imagining that I would actually cook was a yellow Bialetti 10-Inch Nonstick Frying Pan. While the interior of the frying pan's concave basin is all space-age technological innovation, with glossy, black, Teflon-coated steel curving gently up to the perimeter, the exterior is a whole other story. The outside of the body, as well as the handle, are a sparkly banana yellow, the kind of yellow that makes one think of sundresses and lemonade, birds chirping in the window, and fresh-squeezed orange juice in the morning. This is a yellow that takes a stand against the functional black that these ubiquitous Teflon pans have been cast in since their invention. The shape of the handle is also slightly more ornamental than that of a typical frying pan. The handle curves upward, narrows slightly, and then fans outward toward its end. This curvature is not only functional, allowing for a nice grip at the narrow part between the thumb and the forefinger, it also gives the pan a gentle, curvilinear shape that is reminiscent of Art-Deco design.

One final object that found its way into my shopping cart by appealing to my sense of nostalgia was a deceptively simple silicone mixing spoon made by a Seattle–based company called Tovolo. The spoon's design is nothing more than an eight-inch-long, stainless steel elliptical cylinder that terminates in a firm, cherry blossom pink

silicone head, oval-shaped and about four inches in diameter. Design critic George H. Marcus, in his treatise on functionalism, states that "objects made to be used should be simple, honest and direct . . . and expressive of their structure and materials."[1] This spoon's simple design is practically screaming, "Look at my materials!"—and, in fact, the glory of these materials is reiterated in the packaging. Attached to the spoon is a stiff, waxed-plastic label that expounds on the spoon's merits. "Stainless steel handle with silicone spoon designed for comfort and durability," it declares in evenly spaced, sans-serif white font, set against a Kelly green background. It could have been a description from the MoMA design store. Turn the label over and it has even more to say about itself: "Oval handle fits comfortably in your hand, head of the spoon is pure silicone, will not discolor or hold aromas," it states in proud bullet points. "Heat resistant to 600° F/300° C," it proclaims. The packaging goes to great lengths to make sure the consumer understands exactly how modern, functional, and wonderful it is, but when my eyes first fell upon the spoon I could only think of two words: strawberry shortcake. The label tells you that this is a technologically advanced product of the future, but the color says that when you scrape your mixing bowl and lick the unbaked cookie dough off of this spoon, it's going to taste exactly like it used to when you were six years old, baking cookies with your mother.

This new trend of retro-modern cookware coincides with the coming of age of a new generation of high-end consumers. Young professionals in their late twenties and early thirties, just beginning to have enough money to shop at places like Whisk, are extremely technologically savvy and will not accept anything less than perfect functionality; however, they are wary of the ultra-sleek modern design that they associate with '80s and '90s yuppies. Couple this aversion to the un-cool recent past with an intense nostalgic desire to hold on to their fading childhoods, and it's no surprise that hip product designers are developing functionalist objects with classic, old-fashioned looks.

[1] Geroge H. Marcus, "Introduction" in *On Functionalist Design, An Ongoing History* (New York: Prestel, 1995), 9.

Compare and Contrast Essay: Outline

"Identical twins, Roselle, N.J.," Diane Arbus, 1967

"A young man and his girlfriend with hot dogs in the park, N.Y.C.," Diane Arbus, 1971

Introduction

- Introduce Diane Arbus: Freaks, 1960s, New York
- Discuss normality in Arbus's work. What is normal?
- **Snapshot of each photo: 1.** The first photograph depicts a set of identical twin girls, standing in front of a concrete wall, holding hands, and staring directly at the camera.

 2. The second photograph is of a disheveled-looking young couple standing in Central Park, holding hot dogs and looking despondently at the camera.

Thesis: *These photographs are notable both for the captivating encounters they facilitate between the viewers and the subjects and for how the formal composition and printing heighten the mood and emotive power of the moments Arbus has captured.*

Body Paragraph 1: Subject Matter

- **Topic sentence:** In both photographs, the subject matter makes us question our judgments of ourselves and others.
- **How viewers identify with "Identical twins":** Arbus's most famous photograph forces viewers to contemplate normal versus not-normal, self versus not-self.
- **"A young man and his girlfriend":** We identify with couple's disappointment, depression, and uncertainty.
- **Transition:** We can learn more by formally analyzing these images and attempting to discover what makes them so powerful.

Body Paragraph 2: Saturation and Contrast

- **"Identical twins":** Rich blacks and high contrast; subjects look bright and alive.
- **"A young man and his girlfriend":** Gray and muted tones make the couple look despondent and dead; their identities are not well defined and they blend into the background.

Body Paragraph 3: Composition

- Similar composition: Both have a focal point to the right of center.
- Holding hands: Twins are connected all along their bodies, almost look conjoined. The couple in the park have linked arms, but the distance between them makes them seem awkward and unsure about their relationship.
- Both photographs cut off the figures at the knees so that they look uncomfortably close. The viewer cannot escape.

 Quote: *"There are things nobody would see unless I photographed them…"*

Body Paragraph 4: Materials

- The photographs were taken with a Rolleiflex medium format twin-lens reflex camera, which is held in front of the chest, allowing the photographer to engage with subjects face-to-face.
- Unusual perspective relates to the idea of questioning our usual, "normal" way of seeing the world.

Conclusion

- Arbus's work exposes the blurred boundaries between truth, reality, and subjective human experience to show that nothing is absolute and "normal" does not exist.

Compare and Contrast Essay
Identity and Normality: The Photography of Diane Arbus

Diane Arbus made a name for herself in the 1960s by taking candid pictures of transvestites, nudists, giants, dwarves, circus performers, the mentally disabled, and all those who fell under the decidedly politically incorrect umbrella term "freaks." Throughout her career and posthumous legacy she has received much attention for her controversial photographs, which strike such a delicate balance between humanizing and exploiting her subjects. However, what is less discussed is her body of work dealing with "normal" subjects: everyday Americans, hairdressers, children at weddings, and families walking in the park. These photographs are the key to understanding Arbus's work not only because they provide the counterbalance that begs the question, "What is normal?" but also because they allow us to view the subtle quality of her art without the distraction of more scandalous subject matter. There are two photographs in particular that stand out for the strangeness of their normalcy: "Identical twins, Roselle, N.J." (1967) and "A young man and his girlfriend with hot dogs in the park, N.Y.C. " (1971). The first photograph depicts a set of identical twin girls, standing in front of a concrete wall, holding hands, and staring directly at the camera. The second photograph is of a disheveled-looking young couple standing in Central Park, holding hot dogs and looking despondently at the camera. These photographs are notable both for the captivating encounters they facilitate between the viewers and the subjects and for how the formal composition and printing heighten the mood and emotive power of the moments Arbus has captured.

Both of these photographs confront us with unsettling subject matter that causes us as viewers to question our own judgments about ourselves and others. "Identical twins" is perhaps Diane Arbus's most famous photograph because of the way it deals with the nature of identity and perception. Identical twins are simultaneously a strange natural phenomenon and something we accept in society as normal. The way these two stare at us—one faintly smiling, the other with a tight-lipped little frown—invokes our cultural anxiety over normal versus not-normal, self versus

not-self, which is the primary focus of much of Arbus's oeuvre. "A young man and his girlfriend," although not as well known, also forces viewers to consider the basic question of identity and ego. There is nothing "wrong" with this couple, standing arm in arm eating hot dogs. They are not deformed or monstrous in any way, nor are they behaving outside of social norms, unlike so many of Arbus's subjects; they are just a grumpy-looking young couple holding hot dogs in a park. And yet there is something very unsettling about them. Perhaps the way they stare vacantly at the viewer expresses a lack of certainty about identity, forcing us to consider our own discomfort with our personal attempts to project a satisfactory self-image out into the world. Perhaps we see a little too much of ourselves in this young man and woman, wearing clothes that are slightly out of style, eating processed foods, and seeming to express a sort of dissatisfaction with their relationship and current economic status. How these two images affect different viewers, of course, is something about which we can only speculate; however, there is some knowledge to be gained through a formal analysis of these images and an attempt to discover what makes them so powerful.

Although we typically attribute our immediate emotional reactions to how we identify with the subject matter, there are other, more subtle artistic aspects that contribute to our experience of these photographs. One such aspect is the way that color saturation affects the moods of the pieces. Both of these images are black-and-white silver gelatin prints, but they were printed differently to yield very different results. "Identical twins" is very high-contrast, with rich blacks and brilliant whites. The little girls look crisp and sharp; their matching dresses and wavy dark hair are well defined against the white background. This printing choice heightens the sense of liveliness and the spark of energy in the girls' eyes. The clear sharp lines that outline the girls' faces and separate them from the background reiterate their proud self-possession. In contrast, "A young man and his girlfriend" is muted and gray. The couple's charcoal-colored clothing and their dim faces seem to blend into the background. Their blurry hands look almost as though they were made of the same material as the grainy cement path behind them. Their faces are soft and fuzzy, much like the dull and dazed look in their eyes. The young man and woman seem tired and disinterested and

this mood is so greatly enhanced by the lack of contrast between the subjects and the background that they look like they are barely even there. In both cases, the effects of shading and contrast recall very distinct, very familiar states of mind.

Whereas the moods of these two images are dramatically different, the compositional techniques are almost identical. Both photographs depict a pair of people who are connected to each other in some fashion, and in both cases the subjects are positioned slightly to the right of center. This off-center placement is a classic composition and makes the scene look more natural than if the subject appeared in the exact center. The twins are not holding hands, but have their arms leaning flush against each other, creating a seamless continuity between their bodies. This body positioning captures the mysterious connection between twins and also makes them look almost conjoined, suggesting, but not overtly, the taboo of deformity. In contrast, the young couple in the park is linked arm in arm, but slightly distanced, with a sliver of space between them. Whether real or perceived, this distance implies some degree of tension or disconnection in their relationship. A final compositional choice, and a Diane Arbus trademark, is the way that the legs are cut off in both photographs. Arbus cropped these photographs in such a way that the heads are very close to the top of the frame, and the legs run into the bottom of the frame, with the feet and floor cut off and out of sight. This has the effect of making the subjects seem uncomfortably close to the viewer. The twin girls and the couple in the park are right in your face, forcing you to reckon with them and consider them. In Arbus's own words, "It's very subtle and a little embarrassing to me, but I really do believe there are things which nobody would see unless I photographed them."[1] This close-cropping technique reflects Arbus's entire conceptual framework, which exposes both "freaks" and those we might consider "normal" and insists that we, the audience, take a closer look and reconsider our preconceived notions about other people.

A work of art can be considered the point of intersection between three forces: the artist, her subject, and her material. Arbus's subject was human identity, and her material was a Rolleiflex medium format twin-lens reflex camera. This boxy camera design featured a viewfinder on the top, so that the photographer could hold

[1] *Diane Arbus: An Aperture Monograph* (New York: Millerton, 1972), 15.

the camera at waist-level, as opposed to the traditional eye-level camera. This not only gave Arbus a unique low-angle perspective, it also allowed her to engage face-to-face with her subjects while creating their portraits, making a more personal connection possible than what could be achieved with the photographer hiding behind the lens. The resulting unnatural angle increases the awkwardness of the encounters that Arbus photographed. It also tends to put the viewers on the same level as the subjects, neither looking down on them nor up at them. Although this perspective seems to reflect a desire to create equality between viewer and subject, it is impossible to know to what extent Arbus's conceptual choices are the result of this feature of her camera and to what extent she sought out this particular tool to achieve her desired result. Either way, the use of a camera angle that is not "normal" compels us again to contemplate the increasingly slippery slope of normality. Arbus's photographs allow us to take a moment to step outside of ourselves and look at the world literally from a different point of view. This kind of out-of-body experience not only causes us to question all of our assumptions about the world, it also compels us to ask ourselves what makes us, the people on the other side of the lens, so supposedly normal.

There is a long-standing debate as to whether photography has some special ability, which other art forms lack, to capture reality or truth. When we look at photographs like Diane Arbus's from the late '60s and early '70s, it becomes clear that, in fact, photographs can always be manipulated to express a photographer's particular vision of truth. We have seen in "Identical twins" and "A young man and his girlfriend" how saturation, contrast, and camera angle all affect the mood of a photograph, and how the meaning can be changed through cropping. However, it is important to realize that this does not make the images any less real, or "true"; it simply illustrates the subjective nature of all perception. For Arbus, the very inability of human beings to agree on what is real and what is unreal, to accurately label any event as "normal" or "abnormal," or even to define our own identity within the greater context of life on earth, is the greatest truth, and one that must be exposed.

Frequently Asked Questions

FAQs

Can formal analysis include my opinion?

Yes and no. Formal analysis is not exactly fact and it's not exactly opinion. It is observation and response. It must be noted, though, that formal analysis is not just a bunch of "I like this" and "I don't like that." That kind of writing is the result of lazily falling back on the old habits of the mind. You are encouraged, however, to describe your experience of how various formal aspects work or don't work together: how, for example, one color doesn't complement another color; how the composition has a calming sense of balance; or how soft lines beautifully express a melancholy mood.

Generally, in academic writing, it is best to avoid or at least minimize the use of the pronoun "I." However, this does not mean you cannot express your opinion. Trust in the power of adjectives. Describing something ugly as "garish" and "gaudy," or something beautiful as "enchanting" and "exquisite," is much more powerful than writing "I like it" or "I don't like it."

We are all individuals. We come from different cultures and families and have different personal histories, so our responses to a given work of art will also be unique. Formal analysis is not quite opinion, yet it is personal, as each individual will find different details interesting. What you like and what I like may be completely opposite, but we must both be able to express our views in formal terms before we can have a real conversation about anything.

How do I write a thesis statement for a formal analysis essay?

It can seem very challenging to write your thesis statement because a formal analysis paper is not exactly an argument. Usually, a formal analysis serves more for exploring something than for proving a point. Nevertheless, it is helpful to conclude the introductory paragraph with some sort of statement about the purpose of the paper. The best formal analysis papers have a thesis statement that points us in the right direction but doesn't try to explain everything about the piece that is being analyzed. In other words, the thesis statement tells the reader what to look out for in the essay, leaving the deeper meaning to gradually unfold as the various formal aspects of the piece (or pieces) are discussed.

There are many types of essays that utilize formal analysis, and hence there are many types of thesis statements. The thesis statement most often has something to do with whether or not the object is successful; how the formal elements work together to create a certain mood or impression; or how a piece does or does not represent the ideals of a particular art or design philosophy such as functionalism, Expressionism, or user-centered design. The important thing is that your thesis statement indicates what formal aspects you will be focusing on and hints at what sort of conclusions you will draw.

An excellent thesis statement strategy, when you are first getting started, is to write a "place-holder" thesis. You probably have some idea as to what you want to say already, but it may not be possible to write a gloriously polished thesis statement until you have done a complete formal analysis, so don't worry about it too much when you first start writing. Just write a sentence that explains what you think you want to say in basic terms and plan to come back and revise the thesis after you've written the rest of the essay.

In the Diane Arbus essay, my original "place-holder" thesis was: *These photographs are both highly representative of Diane Arbus's work and have very similar composition, but they have dramatically different subject matter and mood.*

After I had written the essay and developed my ideas more thoroughly, I refined the thesis: *These photographs are notable both for the captivating encounters they facilitate between the viewers and the subjects and for how the formal composition and printing heighten the mood and emotive power of the moments Arbus has captured.*

How should I organize my paper?

Writing an essay is like taking a road trip to Chicago. In the introduction you tell us that we're going to Chicago, why we're making the trip, and how we're going to get there. The body paragraphs are the drive itself, where you point out all the interesting and exciting things to see along the way. And in the conclusion, you tell us what the trip meant to you, what you learned, and how you were changed by our Midwest adventure.

The organization section of this chapter offers a basic structural framework in which you begin with larger general topics and move toward smaller, more specific details. This is a helpful approach, but you still have to decide what you think is important for the reader to understand first, second, and last. Do you discuss details chronologically, beginning with what you noticed first, and then introduce things that you only discovered after you'd been studying the piece for some time? Or do you begin with what you think are the most important subjects for under-standing the piece before moving on to interesting, but less essential, details?

There is no simple answer to these questions. Again, think of the road trip meta-phor. When you are telling a friend about a trip you took, do you tell everything in the order that it happened? Do you start with some particular event that seems like the most impressive part and then gradually fill in the rest of the gaps? Or do you deliberately withhold a shocking detail in order to surprise them at the end? These are all valid ways to tell a story and the approach one chooses will depend on the personal preference of the storyteller. A formal analysis essay is, more than anything, a narration of your experience with a piece of art or design, so it's really up to you to decide what kind of story you want to tell.

What should I put in the conclusion?

Many writers struggle with conclusions. How do I end my essay? Should I just write a summary? Often, when a paper concludes with a brief summary of what has already been said, we feel a sort of emptiness. Like our minds are closed. Like there is nothing more to say on the subject and we can stop thinking about it forever now. This is not a good way to end a paper. When we read something—an essay, a book, an article, anything—we want our minds to be opened, not closed.

The conclusion is the place for truth. It is your opportunity to explain what you have learned through the process of writing your formal analysis. If you learned nothing, that means you haven't really done enough. It is a frustrating feeling, but there is only one solution: to go back and look closer. Think deeply about the significance of the observations you have made and how they have changed your understanding of the piece. Surely there is some lesson to be learned from the work you have done, and the conclusion is the place to figure out what that lesson is.

Finally, in addition to contemplating how your formal analysis has changed your understanding of the piece, you should use your conclusion to reflect on how this process has changed your view of the larger world. How do all the compositional elements you observed in this photograph change your understanding of photography in general? How does the concept of user-centered design, which you explored through your analysis of this cell phone, relate to current trends in social media? How has your careful study of the choices this painter made deepened your understanding of how color can be manipulated to express human emotion?

Aa Appendix

Useful Terms and Expressions

Knowledge is the currency of the academic kingdom, and we increase our wealth not with dollars and cents, but with new terms and concepts. Many visual-oriented students find that a great deal of confidence can be gained just by mastering some basic vocabulary. Of course, it is true that each field of art and design has its own specialized language and technical terminology, which can only be fully grasped after one has begun working in that particular environment. Nonetheless, there are many concepts that transcend the limits of any one conversation and are applicable to a wide range of artistic disciplines. The following is a glossary of terms and expressions that come up frequently in academic and professional discussions surrounding visual culture. You may find it helpful, after reading the definitions and examples, to come up with your own examples for each term. We are only able to truly make a word our own once we have identified it within our own unique experience.

A

abstract –adj. *AHB-strakt*

In art, describes work that is more interested in exploring the interplay and effect of line, color, and form than accurately representing the physical world.

Example: Wassily Kandinsky's **abstract** paintings are like little eruptions of visual thought, with multicolored triangles, grids, and curling lines exploding from the center of the canvas.

ahead of his/her time –phrase

An artist or designer whose work is so original and exceptional that it may not be understood during his or her lifetime. Artists who are ahead of their time are often later recognized as brilliant and remain highly influential for generations to come.

Example: Van Gogh was so far **ahead of his time** that it wasn't until the Expressionists of the 1950s, sixty years after his death, that anyone was able to come close to matching his ability to communicate pure emotion with paint and brush.

appropriate –v. *uh-PRO-pree-eyt*

To incorporate readymade external media, such as newspaper clippings or images from the Internet, into one's work without official permission. To directly borrow or steal material, concepts, or images from another artist and incorporate their work into one's own work, usually for the purpose of commenting or criticizing in some way.

appropriation –n. *uh-PRO-pree-ey-shun*

The act or practice of appropriating.

Example: Nearly 100 years after Hannah Hoch first began to use her kitchen knife to **appropriate** photographs and text from newspapers for her collages, we now find ourselves in an era of digital cutting and pasting in which work that includes images or text **appropriated** from the Internet is commonplace.

art star –n.

A young artist who becomes famous very quickly and is typically very involved in the social scenes that surround the art world. Sometimes used negatively to indicate an artist's rock star behavior and trendy artwork.

Example: In 2003, at the age of twenty-five, **art star** Ryan McGinley was one of the youngest artists ever to have a solo exhibition at the Whitney Museum. That same year he was named Photographer of the Year by *American Photo* magazine for his 35mm photos of the young and hip.

avant-garde –n. *ah-vahnt-GARD*

The forefront of something new, usually unorthodox and experimental, especially in visual or conceptual art, music, dance, etc.

avant-garde –adj. *ah-vahnt-GARD*

Belonging to the avant-garde.

Example: In Takami Utzu's **avant-garde** dance production "Shadows of the Immaculate Conception," the dancers perform in complete darkness so that the audience can only hear them and imagine their movements.

B

bourgeois –adj. *boor-JWAH*

Of or characteristic of the middle or upper-middle class. Often carries negative connotations of being pretentious, conventional, or materialistic.

Example: There's some really amazing art in the Chelsea Galleries, but the opening night parties are so **bourgeois**! Everyone just stands around trying to impress each other with their outfits and clever jokes and no one looks at the art.

C

cliché –n. *klee-SHEY*

Something that has been done and redone so many times that it has become lifeless, stereotypical, and boring; unoriginal.

cliché or clichéd –adj. *klee-SHEY or klee-SHEYD*

Having the characteristics of a cliché.

Example: If you had written a song about teen rebellion fifty years ago it would have been cool, but now it's just **cliché**. Maybe you can sell it to Broadway, since all those musical plays are just one **cliché** after another anyway.

composite –n. *kum-PA-zit*

A photographic image, often digital, made up of multiple images to create a seamless whole.

Example: For Miwa Yanagi's series My Grandmothers, the artist created digital **composites** of fantastic imaginary scenes inspired by stories of how teenage girls imagined themselves in fifty years.

connoisseur –n. *ko-nuh-SUR*

A person with a passion for and expert appreciation of a particular thing, e.g., an art form, who is highly aware of the nuances and minute differences between one piece and another.

Example: To me, monochromatic, minimalist painting is pretty much all the same, but to a true **connoisseur**, the subtle shift in mood between an Ellsworth Kelly tangerine canvas and a persimmon-orange painting by Yves Klein is like the difference between Warhol's *Marilyn Monroe* and Da Vinci's *Mona Lisa*.

connotation –n. *kah-no-TAY-shun*

The secondary meaning of a word or symbol; typically refers to the emotions and ideas that a given culture associates with something.

connote –v. *kah-NOTE*

To suggest a secondary meaning.

Example: In the 1960s, images of commercial airplanes had a **connotation** of progress and freedom, but today one cannot help but associate them on some level with terrorism.

context –n. *KON-text*

The time, place, and circumstances in which something appears.

Example: If you saw a six-foot-tall print of a Coca-Cola bottle on the wall in your friend's apartment, you probably wouldn't think too much about it, but if you saw that same print in the **context** of Sotheby's Auction House, with Andy Warhol's signature on it, and a $35 million dollar price tag, you might start to think about what the piece really means.

contrast –n. *KON-trast*
In achromatic art, the sharpness of blacks and whites compared to the softness of grays. Usually coupled with a modifier like "high" or "low."

Example: This underwear advertisement is too low-**contrast**. The model blends into the background. It should be higher-contrast to make her jump right off the page.

contrived –adj. *kun-TRYVD*
Obviously planned. Used to describe a piece of art or design that tries so hard to make a point that it looks artificial or forced.

Example: Although many people celebrated the Hollywood blockbuster *Avatar* for its bold environmentalist message, some critics felt that the simplistic "man versus nature" story line was too **contrived**.

cropping –v. *KRAWP-ing*
In photography, the act of cutting away unwanted parts from the edges of a scene.

Example: Janet never spoke to her cousin Mary again after she learned that she had been **cropped** out of the wedding photos.

crowdsourcing –v. –n. *KROWD-sorss-ing*
The practice of recruiting "volunteer" designers, programmers, and artists from the general public to do specific projects for a company. The idea is that the independent, unknown designer gets the chance to gain recognition for their work and the company saves money, while theoretically getting a better product, advertisement, etc., because it was created by an actual member of the target audience.

Example: In order to launch Facebook in France, the company could have paid translators and programmers millions of dollars to redesign the website in the French language, but instead they **crowdsourced** the project to the French people and the site was completely translated and up and running within twenty-four hours, for free.

cutting-edge –adj. *cuh-ting-EDJ*
The newest and most advanced, particularly with regard to technology or media.

cutting-edge –n. *cuh-ting-EDJ*
The most current or advanced stage of development.

Example: The iPad uses **cutting-edge** touch-screen technology to give users a more intuitive web-navigating experience at their fingertips.

D

denotation –n. *dee-no-TAY-shun*
The direct or literal meaning of a word or symbol.

denote –v. *dee-NOTE*
To indicate the direct or literal meaning of something; to be a mark of.

Example: The four letter word "tree" simply **denotes** a type of plant that has branches and leaves and grows in the earth; but the idea behind it is loaded with personal, spiritual, cultural, and mythological significance.

dichotomy –n. *die-KOT-oh-me*
The division of a whole into two equal parts; opposite sides of a concept, such as rich and poor, black and white, etc.

Example: The simple elegance of the yin-yang symbol achieves balance and harmony between the **dichotomy** of positive and negative space.

didactic –adj. *die-DAK-tik*
Describes art, speech, or media that is meant to instruct or shape public opinion, especially when the artist presents his or her message as morally superior; preachy.

Example: Although Karen's photography series about conditions in Third-World clothing factories addresses an important public health issue, most people found it a bit **didactic**.

diptych –n. *DIP-tik*
In two-dimensional art, a presentation in which two separate images, usually the same size and framed in the same way, appear side by side, often connected by a hinge. The two images will typically complement or comment on each other, or will be parts of the same scene. *See also* **triptych**.

Example: Andy Warhol's *Marilyn Monroe* **Diptych** portrays the pop icon in a grid of vibrant yellow and blue images on the left, contrasting with a grid of faded, smeared black-and-white images on the right. The juxtaposition of the panels suggests a contrast between the star's glowing life and tragic death.

E

ephemeral –adj. *eh-FEM-er-uhl*
Lasting only a very short time; transient.

Example: Part of what makes Marina Abramović's performance art so captivating and powerful is that it is so **ephemeral**; what you are seeing will literally never happen exactly the same way again.

esoteric –adj. *es-oh-TARE-ik*
Only of interest to a small and exclusive group of people; often refers to ancient lost arts, systems of knowledge, and magical practices.

Example: Although anyone can recognize the resonant power and historical weight of ancient Egyptian art, the true significance of Egyptian symbology is too **esoteric** to be understood or appreciated by the general public.

euphemism –n. *YU-feh-mism*
A softer or more polite way of saying something; an indirect but more socially accept-able expression for something that would be inappropriate or offensive if said directly.

euphemistic –adj. *yu-feh-MIS-tic*
Using or having the quality of a euphemism.

Example: It is a grand tradition in advertising to find clever **euphemisms** to help sell products like toilet paper (for "when nature calls"), tampons (for "that time of the month"), and condoms (for "when things start to heat up").

F

formal –adj. *FOR-mal*
In art, having formal qualities of line, color, and composition that are more significant than the subject matter.

Example: Piet Mondrian's **formal** compositions explore the limits of what can be expressed using only primary colors and straight lines.

functional –adj. *FUNK-sha-nul*
In design, having a form that exactly expresses an object's function, with nothing extra

or ornamental added. Also refers to functionalism, a design principle favoring the simple, geometric, and utilitarian and associated with the Bauhaus.

Example: Marcel Breuer's rigidly modern tubular steel and leather armchair sure is **functional,** but I wouldn't want to sit in one because it looks incredibly uncomfortable.

G

gimmick –n. *GIH-mik*
A clever trick or design feature that is used, often repeatedly, to draw attention to an advertisement, artwork, or product and distinguish it from others.

gimmicky –adj. *GIH-mih-kee*
Using or having the quality of a gimmick.

Example: Some have argued that Madonna's cone-shaped bra was a political fashion statement, but it was more likely just a **gimmick** to get people to buy more copies of her album.

grotesque –adj. *groh-TESK*
Bizarre, ugly, disgusting, distorted, deformed; in art, depicting the dark side of the human imagination.

Example: German painter Otto Dix worked with **grotesque** themes during the Dadaist period, painting frightening pictures of horribly wounded or dismembered soldiers, while portraying military generals and politicians as greedy capitalist pigs, feeding at a trough of money and sex.

H

homage –n. *OM-ij* or *oh-MAHJ*
A work, especially of art, music, or writing, that is inspired by and directly related to another artist's work; a tribute. An homage often involves imitation or copying, but in a deeply respectful way that honors the other artist's achievement.

Example: At first it might seem that Quentin Tarantino's *Kill Bill* and *Inglourious Basterds* are poking fun at kung-fu and action cinema clichés, but the care and thought he invests in his scenes indicate that Tarantino's films are more likely a loving **homage** to these genres.

hybrid –n. *HI-brid*

A combination of two or more materials, techniques, functions, styles, disciplines, or philosophies.

hybrid –adj. *HI-brid*

Having the nature of a hybrid.

Example: Cai Guo-Qiang's large-scale gunpowder drawings represent a form of **hybrid** art which combines aspects of performance, technology, and painting.

I

idealized –adj. *eye-DEE-uh-lyzd*

In art, describes work that strives for perfection of form rather than realism, especially with regard to proportion and symmetry. In ancient art, idealized often refers to figurative pieces that are not meant to represent any particular individual, but rather a conceptual body, such as that of the pharaoh, the mother, etc.

Example: To appreciate classical Greek and Roman sculpture, it must be understood that these exquisite marble renderings of men and women were not meant to be strictly realistic, but rather to express an **idealized** beauty that transcends all human imperfections and elevates men to the status of the gods.

idiosyncrasy –n. *ih-dee-oh-SINK-rah-see*

A habit, behavior, or trait unique to an individual person or thing; an imperfection or peculiarity.

idiosyncratic –adj. *ih-dee-oh-sin-KRAH-tik*

Displaying or having the nature of an idiosyncrasy.

Example: Although computer programs are able to generate a variety of geometric forms and simulate hundreds of styles of brushstrokes, they will never be able to replicate the personal **idiosyncrasies** of a line drawn by a human hand.

impetus –n. *IM-puh-tuhs*

The motivation or justification behind something; stimulus.

Example: The lack of safe drinking water in developing countries is the **impetus** for the new water filter I have designed.

innovation –n. *ih-no-VAY-shun*
A new idea or approach, especially in design and technology. *See also* cutting edge.

innovative –adj. *IH-no-vay-tiv*
Introducing or demonstrating new ideas or approaches.

Example: After years of research, Swedish designers Anna Haupt and Terese Alstin have released the "Hövding," an **innovative** bicycle helmet design in which an airbag is housed within a stylish collar and engineered to inflate and encompass a cyclist's head during a collision.

intricate –adj. *IN-trih-kit*
Highly detailed and complex, usually involving many small parts arranged in a delicate and precise manner.

Example: Traditional Islamic decorative art tends to focus on **intricate** geometric patterns and abstract designs, while avoiding figurative representation.

intuitive –adj. *in-TOO-ih-tiv*
Easily understood by a user without any need for instructions; in product design, often refers to digital interfaces that can be navigated using just one's common sense.

Example: The reason Facebook has been so much more successful than other social networking sites is its **intuitive**, user-friendly design.

J

juxtapose –v. *juhk-stuh-POHZ*
To place different objects or images next to each other in order to create a conversation or relationship between them that is often tense, shocking, or unexpected.

Example: The collage **juxtaposes** images of falling bombs and marching soldiers alongside photographs of blooming flowers and smiling babies, creating an unsettling relationship between destruction and growth, violence and beauty.

K

kitsch –n. *KITCH*
Something that is tacky, cheap, low-quality, and often plastic, but may appeal to those with an ironic or genuine affection for bad taste and outdated design.

kitschy –adj. *KITCH-ee*
Having the quality of kitsch.

Example: Oh my god! I can't believe that you have a hamburger phone. That's so **kitschy**, but so awesome!

L

large-scale –adj.
Much larger than traditional examples of a given medium, and proportionally larger than the human body. May refer to a large project that typically requires a team of assistants to assemble or install.

Example: Richard Serra's **large-scale** sheet metal structures create an environment that completely immerses the observer within the sculpture.

M

metadiegetic –adj. *met-uh-die-uh-JET-ik*
In art, refers to something that is self-aware and comments on its own artificial existence. This practice is common in narrative-based art forms such as film and literature, but is also prevalent in postmodern visual art.

Example: The **metadiegetic** technique of having characters look into the camera and talk directly to the audience about how things are going for them in the movie was used in both *Ferris Bueller's Day Off* and *Wayne's World*.

modern –adj. **modernist** –adj. *MAW-dern MAW-der-nist*
Not to be confused with "current" or "contemporary," **modern** describes art and design with an aesthetic that expresses the philosophy of efficiency, industry, geometry, logic, and the triumph of man over nature. This philosophy was the cornerstone of modernism, a movement that defined form and function for the better part of the twentieth century. **Modernist** refers specifically to art and design connected to this movement.

Example: *Line Color Form: The Language of Art and Design*, with its minimalist page layout and bold, sans serif font, was highly influenced by **modernist** theories of communication design.

mundane –adj. *muhn-DEYN*

Ordinary, everyday, or commonplace.

Example: Although the subject matter of On Kawara's date paintings is certainly **mundane**, the concept of documenting every single day of one's existence is indeed fascinating.

N

new media –n. *noo MEE-dee-uh*

New communication technologies, especially those that involve social networking and digital interaction and can be personalized and manipulated.

Example: The current trend toward art that involves audience participation is doubtlessly a result of the cultural effect of **new media**.

O

objective –adj. *ob-JEK-tiv*

(1) Having to do with universal perception; describes something everyone can agree on. (2) Unemotional; not influenced by personal feeling.

Examples: (1) Of course there is no such thing as **objective** beauty, but Gustav Klimt's paintings come close. (2) Even though you love your own art, you have to learn to be **objective** during critique or you're not going to hear anyone's suggestions.

oeuvre –n. *OHV-ruh*

An artist, writer, or composer's entire collection; one's life's work.

Example: Pablo Picasso's **oeuvre**, begun when he was seven and completed over the next eighty-four years, includes an estimated 50,000 paintings, sculptures, drawings, and other works of art.

one-liner –n. *won LY-ner*

A piece of art whose entire conceptual meaning can be summed up in one line; simple-minded or superficial art.

Example: I really don't like John's new collage about the garbage left behind by wasteful consumerism. It's an important issue, but it's just such a **one-liner**.

outsider art –n. *OWT-sy-duhr art*

The work of artists who lack formal training, have little or no contact with the mainstream art world, are sometimes mentally disabled, and who often remain largely unknown until after their deaths.

Example: The art world was shocked by the discovery of **outsider artist** Henry Darger's 15,000-page fantasy science fiction novel, *The Story of the Vivian Girls, in What is known as the Realms of the Unreal, of the Glandeco-Angelinnian War Storm, Caused by the Child Slave Rebellion*, found in his apartment after his death along with hundreds of paintings and drawings illustrating the story.

P

paradigm –n. *PAIR-uh-dime*

A set of beliefs or assumptions that inform all scientific and artistic endeavors during a given era in human history.

Example: Cubism marked the beginning of a new **paradigm** in visual art, when the idea of an idealized, individual viewer was shattered by the concept of multiple perspectives.

parody –n. *PAIR-uh-dee*

An imitation of a well-known person or thing, meant to be humorous, especially common in television, film, and web-videos.

parody –v. *PAIR-uh-dee*

To create a parody of.

Example: Most people will agree that **parodies** like *Scary Movie* and *Not Another Teen Movie* are tasteless and juvenile, but they are so cheap to produce that they're almost guaranteed to make a profit at the box office.

plasticity –n. *plas-TIS-ih-tee*

Having the quality of being infinitely malleable and adjustable.

Example: The **plasticity** of digital environments has revolutionized communication design from a static conversation of images to a new medium capable of responding to user activity in real time.

posthumous –adj. *POHZ-choo-muhs*

Continuing or occurring after an artist or designer's death; typically refers to awards or exhibitions, as well as work published or released.

Example: Just months after the designer's tragic death, the Alexander McQueen Company released its first **posthumous** collection, an underwear line featuring many of McQueen's classic prints.

precursor –n. *pre-KUR-ser*
Something that comes before something else and announces what is to come; an art or design innovation that precedes and leads to later developments.

Example: The early-twentieth-century Cubist experiments of Picasso and Braque can be seen as **precursors** to the entire postmodern era of split subjectivity and multiple perspectives.

prolific –adj. *pro-LIF-ik*
Creating a very large amount of work in one's lifetime, usually working constantly and producing pieces at an astonishing rate.

Example: In 2008, the Guggenheim Museum held a retrospective for Louise Bourgeois, who was ninety-six years old at the time. The exhibition illustrated how amazingly **prolific** the artist had been, filling the museum's seven spiraling floors with just a small sampling of her paintings, sculptures, and installations.

Q

quixotic –adj. *kwik-SAH-tik*
Behaving like the literary figure Don Quixote: impulsive, romantic, and visionary, but ultimately impractical.

Example: Many young artists throw themselves head over heels into **quixotic** projects and then find themselves disappointed when they fail to change the world.

R

ready-made –adj. *RED-ee-meyd*

readymade –n. *RED-ee-meyd*
Also: **found art** –n. **found object** –n.
Refers to a mass-produced object purposefully placed in a museum or gallery by an artist, or several such objects combined to form a sculpture.

Example: Marcel Duchamp forever changed the boundaries of what could be consid-

ered art in 1917 with his most famous **ready-made** piece, *Fountain*, which he created by taking a urinal, signing it with a fake name, and placing it in the middle of a gallery.

reiterate –v. *ree-IT-uh-reyt*

To repeat an idea; in art and design, to repeat or reference another element in the same piece.

Example: The red, white, and gold labels on the packs of cigarettes are **reiterated** by the faded red shirt, white cowboy hat, and tan leather pants that the model is wearing in the advertisement.

rip off –n. *RIP-awf*

The act or product of copying another artist's concept or aesthetic and claiming it as one's own work.

rip off –v. *RIP-awf*

To copy or steal a concept or aesthetic and claim it as one's own.

Example: Karen's candid photographs of her friends doing drugs and sleeping with each other are visually shocking, but she's basically just **ripping off** Nan Goldin's photo-documentary work from the 1980s.

risqué –adj. *rih-SKAY*

Sexually provocative or daring, often pushing the boundary of what is considered socially acceptable.

Example: The monokini, a reduced version of the bikini which consisted of a single bottom piece and no top, enjoyed a brief popularity in the 1970s, but was a bit too **risqué** for the general public, and largely disappeared from the American sunbathing scene by the 1980s.

run-of-the-mill –adj.

Also: **generic** –adj. *juh-nair-ik*

Ordinary, everyday, commonplace; refers to art or design that does not stand out as being unique in any way.

Example: There's really nothing special about J. Crew's menswear line; it's just a bunch of **run-of-the-mill** v-neck shirts and khaki pants.

S

saturated –adj. *SAH-chuh-rey-tid*
Refers to color lacking white and gray; deep and intense.

Example: Roy Lichtenstein used bold, **saturated** colors in his comic book paintings to grab the viewer's attention. This type of color choice is common in pop art, which draws from advertising and consumer culture.

saturation –n. *sah-chuh-REY-shun*
The depth or intensity of a color.

seamless –adj. *SEEM-liss*
In fashion, lacking any visible threads or sewing lines; in art and design, combined without any visible divisions so that the composite appears to be one continuous image.

Example: To create his surrealistic images, Gregory Crewdson takes hundreds of photographs of people and objects from different distances and angles and combines them into one **seamless** landscape.

series –n. *SEER-ees*
In art, a collection pieces created continuously over a period of time, with a similar theme or aesthetic, and usually presented together in a single exposition.

Example: Rising art star Ryan Trecartin's new **series** of seven interconnected movies, titled *Any Ever*, is being shown at MOMA's PS1 from June 19–September 3.

subjective –adj. *sub-JEK-tiv*
Having to do with individual perception.

Example: Everyone will have their own **subjective** experience when they view a work of art, so there's really no way an artist can predict exactly how his or her work will affect an audience.

sublime –adj. *suh-BLYM*
Overwhelmingly beautiful or terrifying; larger and more powerful than ordinary experience, full of mystery and power, inspiring awe.

Example: Traditional Chinese landscape painting, with its vast mountain ranges and great misty voids, inspires a sense of the **sublime** experience of nature.

sustainable –adj. *suh-STAYN-uh-buhl*

Capable of remaining functional over a long period of time without exhausting available materials or natural resources. Typically reflects the values of energy conservation, environmentalism, and green design.

Example: MIT's D-Lab has developed a new form of charcoal made from the wasted plant materials left over from sugarcane production. This more **sustainable** cooking fuel, which burns cleaner than wood, is being implemented in Haiti.

synthesis –n. *SIN-thuh-sis*

The combination of two or more elements or components to create something new.

synthesize –v. *SIN-thuh-syz*

To combine two or more elements or components to create something new.

Example: Google has become the most powerful communications company in the world because it has been very successful in **synthesizing** information distribution and advertising.

T

tongue-in-cheek –adj.

Meant to be humorous and ironic, making fun of itself, while still maintaining the traditions and conventions of its genre. Describes a work that toes the line between being serious and being a joke.

Example: Diesel's **tongue-in-cheek** "Be Stupid" campaign features advertisements that portray models participating in idiotic and dangerous activities while wearing Diesel clothes. It is difficult to figure out exactly what the message is, but it certainly grabs one's attention.

topical –adj. *TA-pih-kul*

Of or relating to topics regarded as current or relevant, especially political or social. Sometimes used negatively to describe work that lacks depth or personal investment because it is too concerned with seeming current.

Example: I know he's trying to be edgy, but Kenneth's new series of portraits of drug traffickers is just too **topical**.

transcend –v. *tran-SEND*
To rise above or beyond limitations or boundaries.

transcendent –adj. *tran-SEN-dent*
In art, music, literature, etc., causing one to rise above and beyond ordinary human experience, lifting the viewer, listener, or reader outside of his or her physical body to reach a higher place.

Example: Classical masterpieces such as Beethoven's *Moonlight Sonata* are **transcendent** in part because their pure, formless beauty lacks any tangible referent in the physical world.

transparent –adj. *trans-PAIR-unt*
See-through, like glass or plastic; also used to describe something that is meant to be hidden, but is nevertheless easily understood or obvious.

Example: When fashion designer Anthony Milan launched his line of **transparent** dresses, many critics commented that his motivation—to expose women's naked bodies—was rather transparent as well.

triptych –n. *TRIP-tik*
In two-dimensional art, a presentation composed of three separate images appearing side by side, often as a three-panel piece with a large central panel and two smaller side panels. Typically, the three images complement or comment on each other, or they are parts of the same scene. *See also* **diptych**.

Example: Hieronymus Bosch's masterful **triptych** painting *The Garden of Earthly Delights* depicts human history as a garden of temptation and pleasure in the center panel, flanked on either side by heavenly and hellish visions.

U

unorthodox –adj. *un-ORTH-uh-doks*
Unusual, out of the ordinary; describes something or someone operating outside of the established way of doing things.

Example: One of the more **unorthodox** of Yves Klein's experimental painting techniques involved laying canvases down on the floor and dragging naked women dipped in paint across them.

V

visceral –adj. *VIH-sur-uhl*
Having to do with the body; usually describes a piece of art or performance that is so strong that it causes a physical reaction in the spectator, particularly feelings in or around the stomach and intestines, such as excitement, nausea, or fear.

Example: Feminist performance artist Sarah Cooper's staged reenactment of a graphic rape scene was so **visceral** that several disturbed audience members left before the performance was over.

voyeuristic –adj. *voi-UH-ris-tik*
Involving watching while being unobserved oneself; describes activities such as spying, watching pornography, or looking at profiles on social networking sites such as Facebook.

Example: The Internet has allowed for rapid communication and almost limitless self-expression, but it has also given us a medium in which to indulge our most **voyeuristic** desires.

Z

zeitgeist –n. *ZAIGHT-gayst*
The spirit of the times; the philosophical outlook, general attitude, prevailing beliefs, and values of a particular culture in a particular time and place.

Example: The **zeitgeist** of the Modernist period was characterized by a belief that men could, and in fact should, use their intellectual and industrial power to conquer nature and build a great new world on the principles of logic and order.

Index

gloomy, 39
luxurious, 37
pastel, 35
vibrant, 38
warm, 32
comparison. *See* sample essays:
 compare and contrast
composite, 103
composition, 40–53
concave, 14
conclusions. *See* formal analysis:
 conclusion
connoisseur, 103
connotation, 103
context, 76–79, 103
contrast (in achromatic art), 30, 104
contrived, 104
cropping, 94–95, 104
crowdsourcing, 104
da Vinci, Leonardo,
 *General and Exploded View of a
 Hoist*, 11
Dalí, Salvador, 42–45
 *Slave Market with the Disappearing
 Bust of Voltaire*, 42
de Zurbarán, Francisco
 *Virgin Mary with Child and the
 Young Saint John the Baptist*, 39
denotation, 105
depth, 16, 42–45, 46–47
design
 curvilinear, 4, 13, 64, 87, 88
 editorial, 48–49, 51–53
 graphic, 47–49

modern, 12–13, 47, 64, 75, 86–89,
 109
postmodern, 14, 65, 71
product, 12–13, 64–65, 75, 86–89
 See also functionalism
dichotomy, 105
didactic, 105
diptych, 105
ellipse, 8, 14
ephemeral, 106
esoteric, 106
euphemism, 106
eye level, 44
 See also perspective
fashion, 48–49, 52, 66–67
focal point, 43, 47
focus, center of, 43
form, and function, 76–79
 See also formal analysis
formal analysis, 84–95
 conclusion, 99
 frequently asked questions, 96–99
 meaning, 82–83
 observation, 76–79
 and opinion, 96
 organization, 80–81, 98
 snapshot descriptions, 74–75
 thesis statement, 86, 90, 97
 See also sample essays
frame, organization of, 41
functionalism, 12, 54, 106
gaze
 feminine, 50–51
 masculine, 52–53

Books from Allworth Press

Allworth Press is an imprint of Skyhorse Publishing, Inc. Selected titles are listed below.

Brand Thinking
by Debbie Millman (6 x 9, 336 pages, paperback, $19.95)

Design Firms Open for Business
by Steven Heller and *Lita Talarico* (7 ⅜ x 9 ¼, 256 pages, paperback, $24.95)

The Elements of Graphic Design, Second Edition
by Alex W. White (8 x 10, 224 pages, paperback, $29.95)

Advertising Design and Typography
by Alex W. White (8 ½ x 11, 220 pages, paperback, $50.00)

Designing Logos: The Process of Creating Symbols That Endure
by Jack Gernsheimer (8 ½ x 10, 224 pages, paperback, $35.00)

Color Management, A Comprehensive Guide for Graphic Designers
by James T. Drew and Sarah A. Meyer (8 ½ x 11, 224 pages, paperback, $19.95)

Thinking in Type
By Alex W. White (6 x 9, 224 pages, paperback, $24.95)

How to Think Like a Great Graphic Designer
by Debbie Millman (6 x 9, 248 pages, paperback, $24.95)

POP: How Graphic Design Shapes Popular Culture
by Steven Heller (6 x 9, 288 pages, paperback, $24.95)

Design Disasters: Great Designers, Fabulous Failures, & Lessons Learned
edited by Steven Heller (6 x 9, 240 pages, paperback, $24.95)

Green Graphic Design
by Brian Dougherty with Celery Design Collaborative (6 x 9, 212 pages, paperback, $24.95)

Designers Don't Read
by Austin Howe; designed by Fredrik Averin (5 ½ x 8 ½, 208 pages, paperback, $19.95)

Designers Don't Have Influences
by Austin Howe (5 ½ x 8 ½, 224 pages, paperback, $19.95)

AIGA: Professional Practices in Graphic Design, Second Edition
Edited by Tad Crawford (6 ¾ x 10, 336 pages, paperback, $29.95)

Business and Legal Forms for Graphic Designers, Third Edition
by Tad Crawford and Eva Doman (8 ½ x 11, 160 pages, softcover, $29.95)

Graphic Designer's Guide to Pricing, Estimating, and Budgeting, Third Edition
By Theo Steven Williams (6 x 9, 256 pages, paperback, $24.95)

Creating the Perfect Design Brief, Second Edition: How to Manage Design for Strategic Advantage
by Peter L. Phillips (5 ½ x 8 ¼, 240 pages, paperback, $19.95)

To see our complete catalog or to order online, please visit *www.allworth.com*.